DRAGONART™
EVOLUTION

How to Draw Everything Dragon

J "NeonDragon" Peffer

IMPACT
CINCINNATI, OHIO
www.impact-books.com

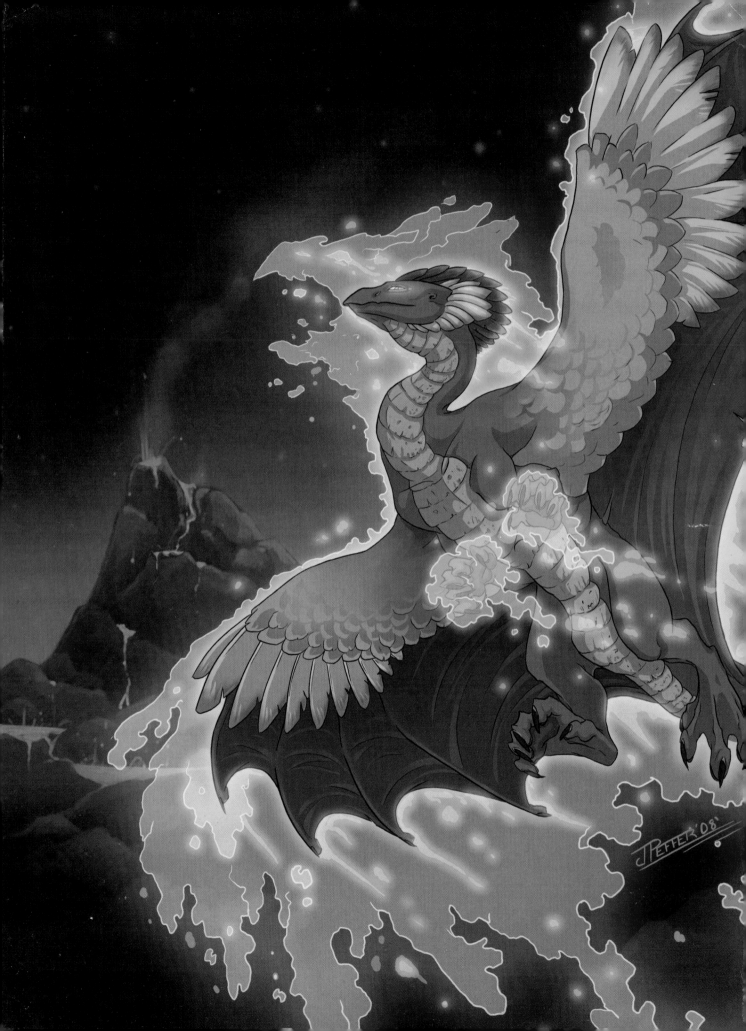

Contents

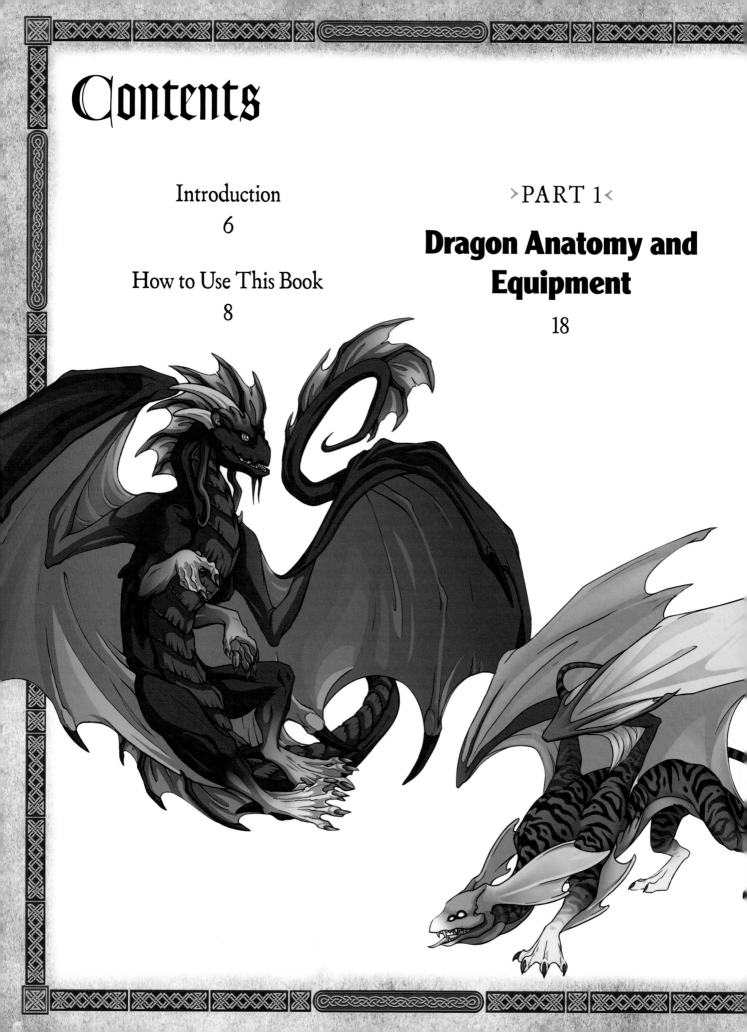

>PART 1<

Dragon Anatomy and Equipment

18

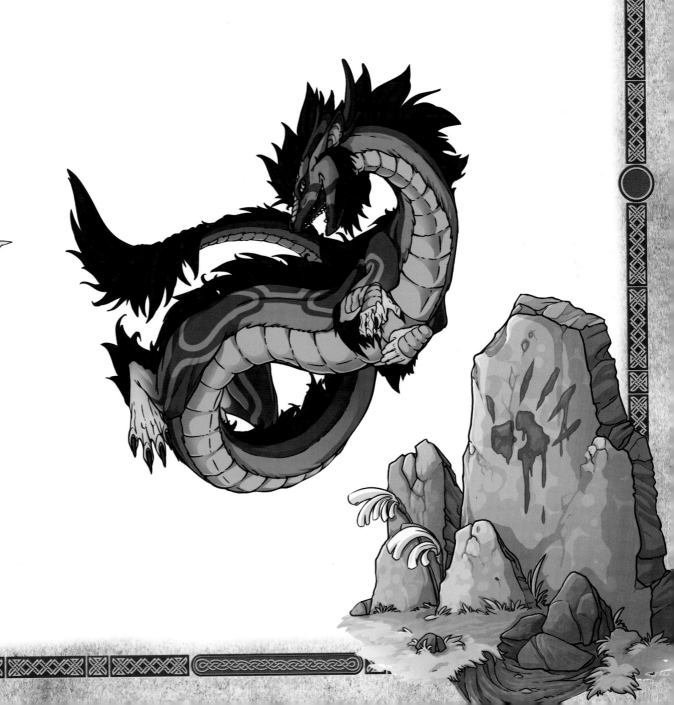

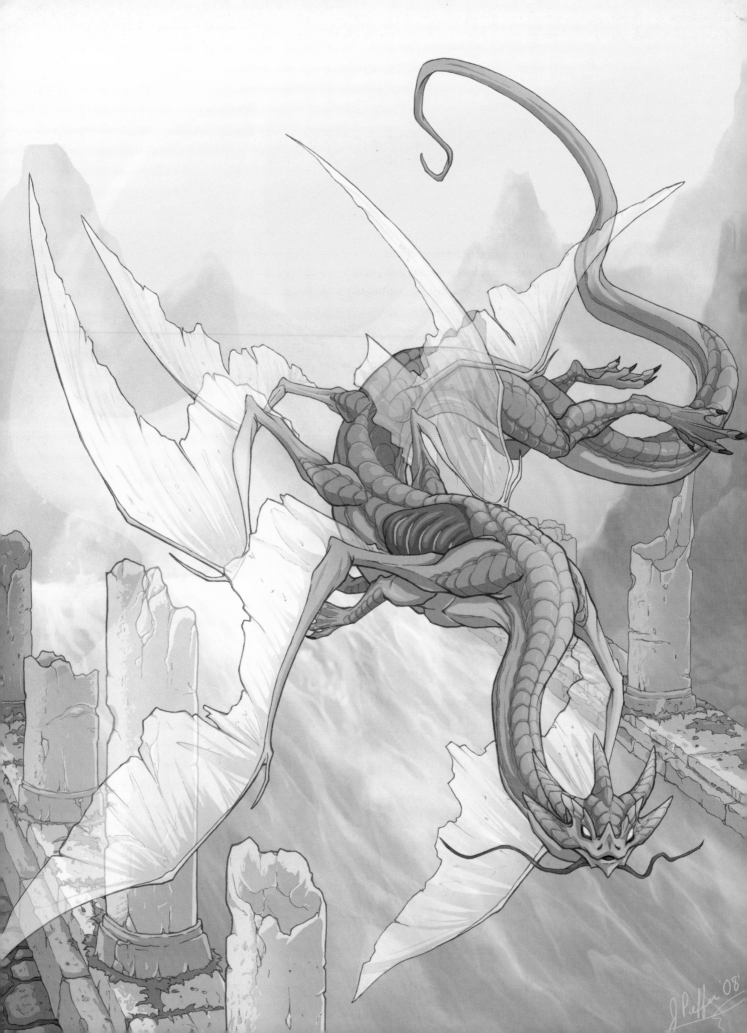

INTRODUCTION

If you've picked up this book, chances are good that you're
a fan of fantasy, myth and dragons. I must commend you on
your most excellent taste! Inside you will find step-by-step
demonstrations, breakdowns on pieces of anatomy, color
theory and illustrations of ways that one could visualize
these creatures of myth and magic.

I hope that you use these demonstrations as sources of
inspiration and foundations for drawing and designing
dragons, rather than the end-all book on the subject. By no
means let what's sandwiched between these pages limit your
imagination or the many, many ways that you can design
your own unique dragons!

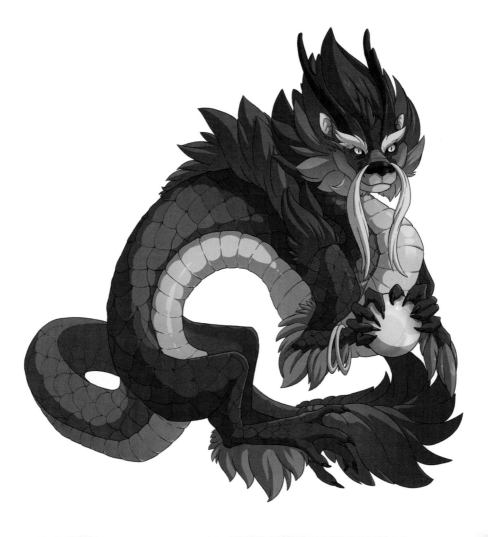

HOW TO USE THIS BOOK

If you're familiar with my other books, you're well aware of how things work. But for the uninitiated, I offer this advice for working through the exercises. This book consists mainly of easy-to-follow step-by-step demonstrations. Each new step of each demonstration is denoted in red or green. Following along with the demonstrations will help you draw several different, truly extraordinary creatures. With this book, we bring back Dolosus, your fierce dragon guide introduced in the first *DragonArt*™. He shows up here and there to provide helpful tips and tricks to ease your passage.

Don't be discouraged if your first efforts don't look exactly as you planned. Everything comes with practice. The more you draw, the better you'll get. Through sheer repetition, your drawings will improve and your own personal style will emerge. If each drawing you make looks a little bit better than the previous one, you're getting somewhere.

So sharpen your pencils, find your softest eraser, prepare your trusty inking pen, and let's go!

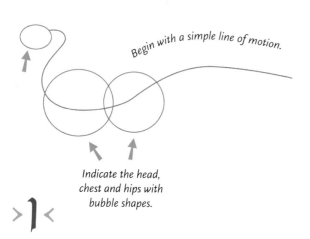

Begin with a simple line of motion.

Indicate the head, chest and hips with bubble shapes.

>1<

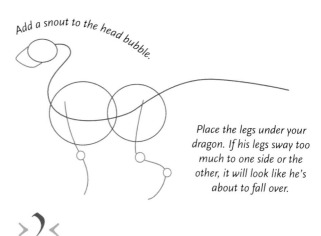

Add a snout to the head bubble.

Place the legs under your dragon. If his legs sway too much to one side or the other, it will look like he's about to fall over.

>2<

Hello, human. I must congratulate you on your excellent choice of reading material.

Perhaps you are not quite as **hopeless** as the rest of your species.

I'm pleased to tell you that **DragonArt™ Evolution** is only about dragons, cover to cover.

All the wonder and magic of dragonkind without any of the lesser creatures to sully its majest...

Hi!

AHH! Leave these pages at once, minion!

You will taint the book with your presence.

But I wanted to help.

Sorry. Dragons only. You can't stay.

...

Continued employment! HOORAY!

DRAGON BASIC SHAPES

First things first. Before you can dive into drawing beautiful beasts, you need to arm yourself with some drawing basics. The easiest way to think about drawing anything is to think of everything as shapes. Anything you would ever want to draw—tables, chairs, flowers or unicorns—consists of simple shapes.

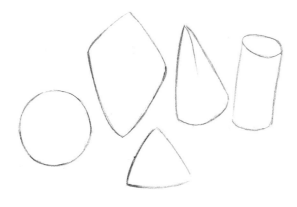

Basics Lead to Beasties
Practice drawing these simple shapes before moving on to more complicated forms.

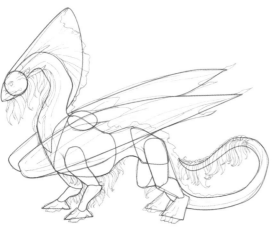

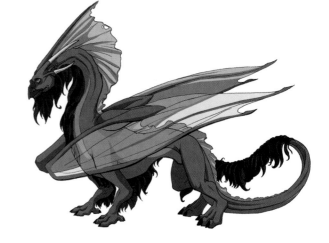

Drawing Any Creature Begins With Basic Shapes
Every dragon or creature you'll learn about in the pages to follow will begin with simple shapes such as these.

Tools You Need

The wonderful thing about drawing is that you really don't need much—your own imagination is the most important thing. To get what's in your head down on paper, though, you will need:
• Some pencils and a pencil sharpener
• A kneaded eraser
• Paper
That's all that's required to propel yourself into fantasy-creature creation readiness!

DRAGON SHADING AND 3-D EFFECTS

Dragons appear more realistic when you draw them to look three-dimensional. It isn't as hard as it sounds. You just have to pay attention to darks and lights and how they affect your creature.

Consider first where the light is coming from. This is called the *light source*. Where the light source hits your dragon or other object is the lightest spot, called the *highlight*. The rest of your creature will likely be in some stage of shadow. As you develop your skills at shading the shadow areas, your creatures will begin to take on new life.

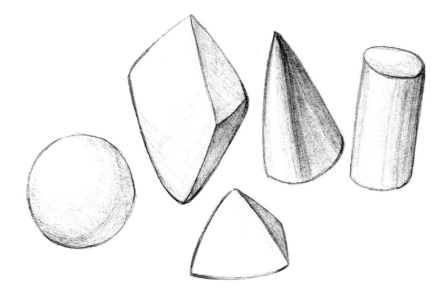

Practice on Simple Shapes

Polygons (shapes with three or more sides) will often have one side facing the light source. This side will be considerably lighter than those angled in a different direction. Sides that are completely cut off from the light will be very dark, giving you a harsh edge.

With round objects there is no clear definition of where things get cut off from direct light. The answer to this problem is fairly simple: Because there's a gradual cutoff from the light, you will have gradual shadow with no harsh edges! Figure out where your light is hitting directly, and as things move farther away from that point of light, they should get darker.

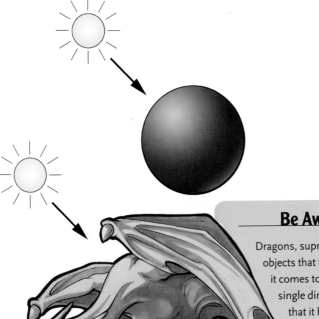

Be Aware of the Light Source

Dragons, supreme though they are, remain solid, tangible objects that follow the same laws as everything else when it comes to light source. Lighting that comes from a single direction will yield highlights on the surfaces that it hits, and shadows on the areas blocked off from the rays.

PERSPECTIVE AND OVERLAP

Overlap is a great tool for creating *perspective*, the illusion of space, and is arguably one of the more important aspects to creating drawings full of depth. When you draw one object or part of an object overlapping another, the object in front automatically looks closer while the one in the back looks farther away.

You can use overlapping objects to create a sense of perspective not only in individual creatures but also in whole scenes. Draw a mountain, then a house overlapping it followed by a dragon overlapping the house and you've got a foreground, middle ground and background. Once those are clearly defined, you've got a believable drawing.

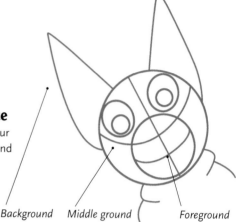

Overlapping Defines Your Space

Overlapping shapes help clearly define your foreground, middle ground and background and give friendly dragons like this one a clear sense of solidity.

Background *Middle ground* *Foreground*

No Perspective or Overlap

Without any overlap or perspective, it is difficult to get an idea of the scale of things. It is also difficult to think of the object as existing within a space. It's lost, floating on the paper.

Overlap Gives a Sense of Order and Ground

Overlap provides a sense of space. The brain registers that one object must be in front of the other.

Overlap Plus Size Variation Provide More Perspective

The green dragon is smaller than the brown. When we see it though, we don't think he's actually smaller than the brown. We just assume he's farther back in the space that they share.

Overlap Plus Size Variation Plus Atmosphere Equals Perspective to the Max!

Atmospheric perspective means that things that are closer appear brighter, have greater contrast and look more in focus. As they recede, all these effects fade. Using all three perspective techniques gives the viewer a good sense of depth.

COLOR AND PATTERN CONSIDERATIONS

Choosing the coloration for your dragon is as important as having a unique, anatomically believable design. The right colors can make your dragon shine, while the wrong ones can make it cringe-worthy. When talking about color, there are a few terms you might run into:

Hue refers to where on the color wheel or rainbow the color falls.

Value refers to how light or dark the color is.

Chroma refers to how intense the color is.

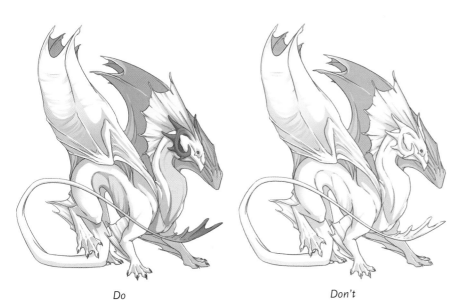

Do

Don't

Pure White Vs. White Isn't White

So you thought you'd start simple and just make your dragon white: Remember that white isn't really white. You can use a variety of light grays and pastel tints to add more interest.

Do

Don't

Saturated MS Paint Colors Vs. Neutral Colors

When choosing colors for your dragon, remember that they don't always have to be the brightest, most chromatic version of that hue available. Sometimes a less chromatic brick red can be more effective than an eye-popping one.

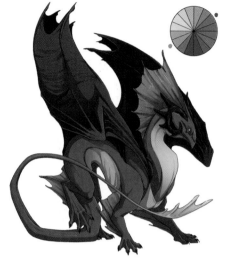
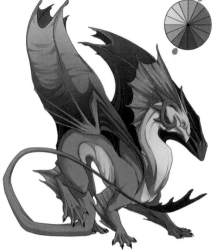

Complementary Colors

When choosing a color combination, a set of complementary colors can often produce a lovely result. The complement will always be across the color wheel from its opposite.

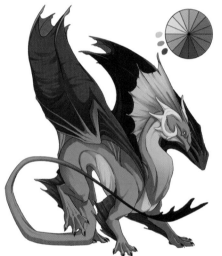
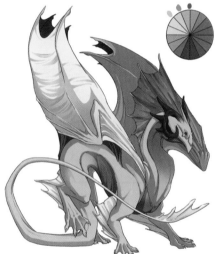

Analogous Colors

Another color strategy is to work in a color family, and not deviate too much in hue. Using a variety of yellow-greens, greens and blue-greens creates more interest than painting the entire dragon the same color all over.

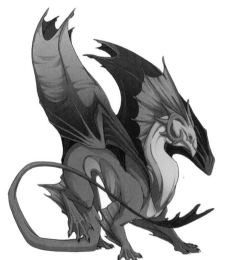
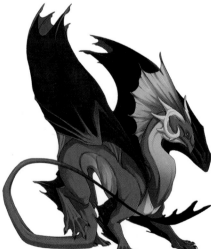

Chroma Contrast

When a bright, chromatic color is placed next to neutral colors, it will seem to "pop" and almost glow. This same red placed next to equally chromatic colors does not have this effect.

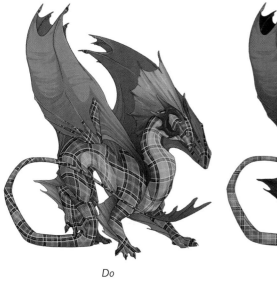

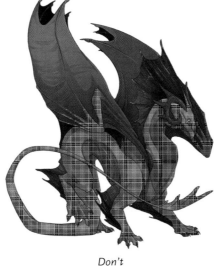

Do *Don't*

Pattern Bends Around Form

If you create a pattern, color gradation or marking, remember that it will bend around the surface of your dragon's skin. The dragon is supposed to mimic a three-dimensional creature. Another don't: Making your dragons plaid to begin with.

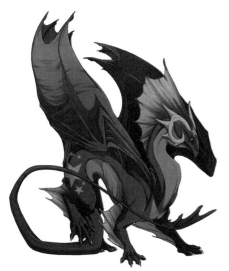

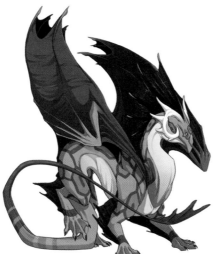

Inorganic Patterns

Geometric markings can be quite fun to play with visually, though this can result in making your dragon look more like it is tattooed than born with markings.

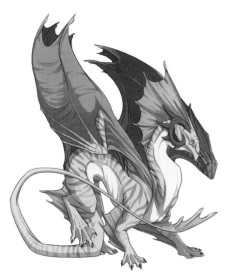

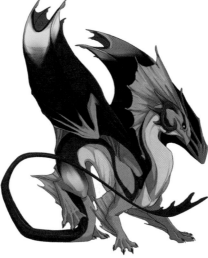

Organic Patterns

If you want to apply an elaborate pattern to your dragon but don't know what to do, existing plants and animals can be a great source of inspiration. The dragon on the left mimics a tiger's stripes, while the one on the right mimics the pattern of a blue tang.

Color Gradients

Gradiating your dragon's color towards its extremities is a strategy you can use to add more interest (left). Color gradients don't have to be on the extremities only, though. You can also create blended spots of contrasting color to add flare (right).

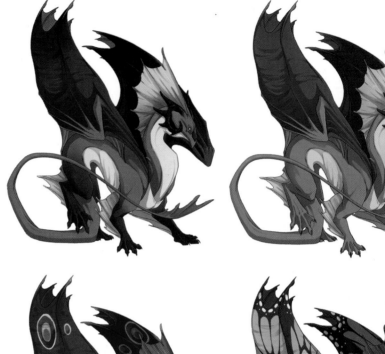

Wing Patterns

Perhaps the markings on your dragon aren't on its body at all, but on its wings. As with body patterns and markings, wing patterns can be borrowed from nature or something you've created from your own imagination.

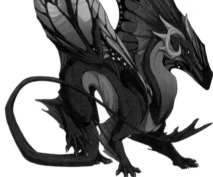

Bringing It All Together

You can use a variety of patterns, fades, complementary, chromatic and neutral colors in a variety of combinations to create an awesome look for your dragon. All the things we've covered so far are just ideas and general guidelines...just remember not to go overboard.

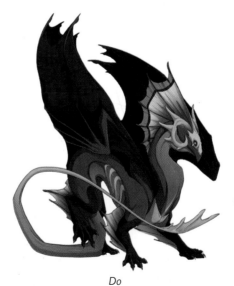

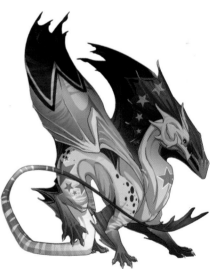

Do *Don't*

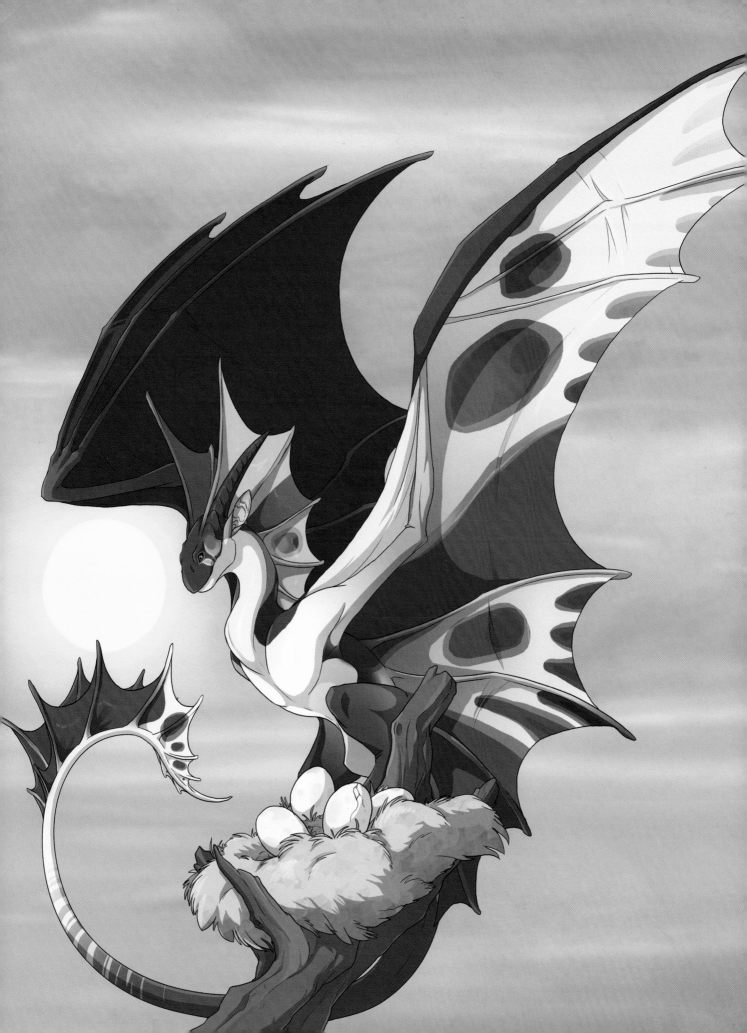

> PART 1 <
DRAGON ANATOMY AND EQUIPMENT

Though dragons are creatures of fantasy and imagination, having solid anatomy is as important as if you were drawing an animal from the real world. Though people have never seen a dragon in the flesh, you want to make them believe it's possible! Having good proportions, skeletal structure and musculature will go a long way toward making your dragons believable. In the following units we're going to go over different ways to approach drawing the different pieces of anatomy. Though I've tried to include several different approaches for each piece, it's important to note that these are merely suggestions and you should not let the following pages limit you or your imagination. There are many ways to create an anatomically sound creature, and I encourage you to explore them all.

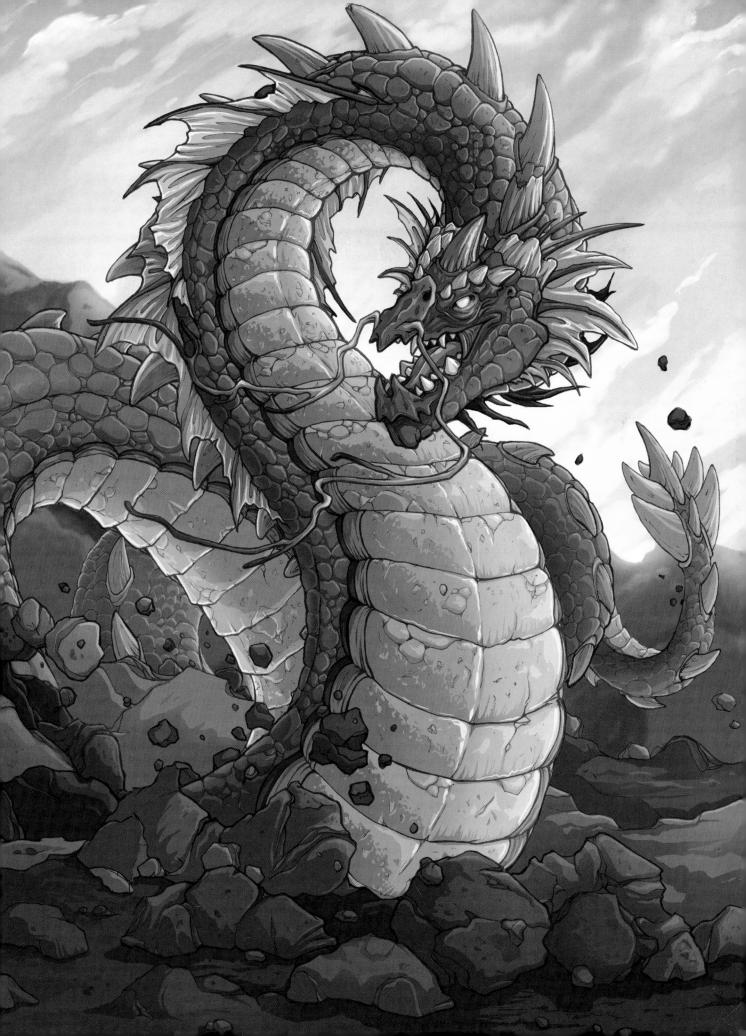

EYES

There are some general steps to follow for eyes.

1 Draw a circle so we know the bounds of the entire eye independent of the socket and face it will be sunken into. Inside the orb of the eye, draw another circle for the iris.

2 Draw the brow and eyelids around the eye. Put a tear duct in the inner corner created by the eyelids. Consider whether you want the skin around the eye to be wrinkly, scaled or smooth.

3 Clean up your sketch and remove any stray construction lines. Refine your drawing and add in any minute details you wish.

4 Color the eye.

ORB EYES

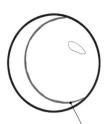 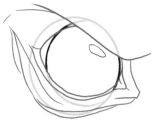 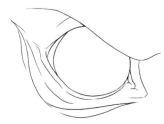 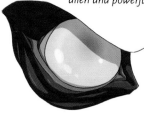

Eyes without pupils make a dragon look alien and powerful!

>1<
These don't have a pupil and iris as we know it, but this glassy circle will be a different color and value than the eye around it, so it's worth sketching out.

>2<

>3<

>4<
When you color this eye, consider making it glassy or glowing with an inner light.

REPTILE EYES

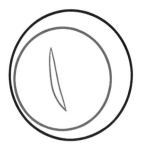 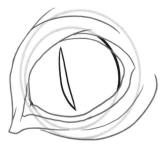 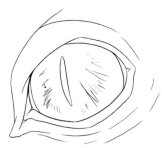 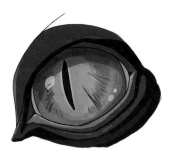

>1<
Draw a slit pupil in the middle of the iris. It may curve slightly because the shape of the eye is round and the pupil will bend around it.

>2<

>3<

>4<
Ringing the slit pupil of the eye with a slightly lighter variation of the iris color enhances the reptilian appearance.

ROUND PUPIL EYES

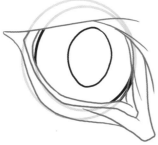

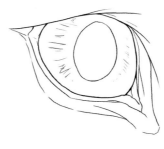

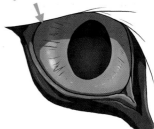

Consider color variations such as flecks of gold inside the iris.

Inside the iris, add a smaller circle in the center for the pupil. Depending on how much light is hitting the eye, make the pupil very small (bright light) or very large (low light).

>1< >2< >3< >4<

JEWEL EYES

>1< >2< >3< >4<

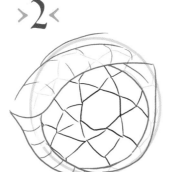

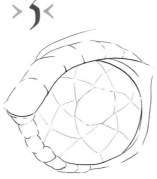

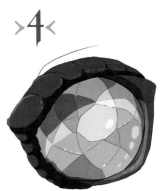

This eye has many planes. Make these facets angle around the eye so that it still appears to be a fairly round three-dimensional shape.

Draw the brow and eyelids around the eye. Put a tear duct in the inner corner created by the eyelids. Consider whether you want the skin around the eye to be wrinkly, scaled or smooth.

You may wish to soften the lines that define the facets of the eye, as you can really make the facets pop with color alone.

When you color and shade your eye, the planes of the facets may be left in shadow or bright highlight, giving it a subtle mosaic effect.

OVERBITE JAW

Here, you'll learn how to draw an overbite jaw in both a closed and open position. Like the rest of the facial features, there are some similarities. Note that the dragons in this demo are for jaw example purposes only and are lacking any embellishments.

1 Draw the upper portion of the skull and jaw and the lower jaw/mandible. The upper portion of the jaw should overlap the lower.
2 Add ridges above the eyes.
3 Pencil in nostrils.
4 Erase stray construction lines and refine your drawing.
5 Color!

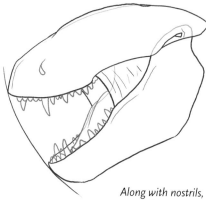

OPEN OVERBITE

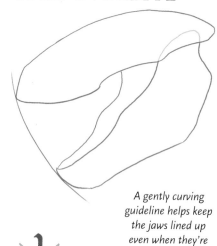

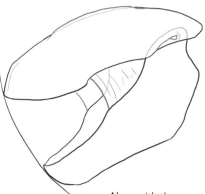

A gently curving guideline helps keep the jaws lined up even when they're open.

>1<

Along with the eye ridges, add the a stretchy piece of skin on the corner of the mouth.

>2<

Along with nostrils, pencil in a set of wicked teeth.

>3<

CLOSED OVERBITE

Along with the eye ridges, add the cheekbones.
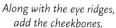

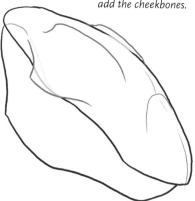

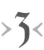

Here the upper jaw extends out over the lower, creating an overbite. How extreme you want to make your overbite is up to you.

>1<

>2<

>3<

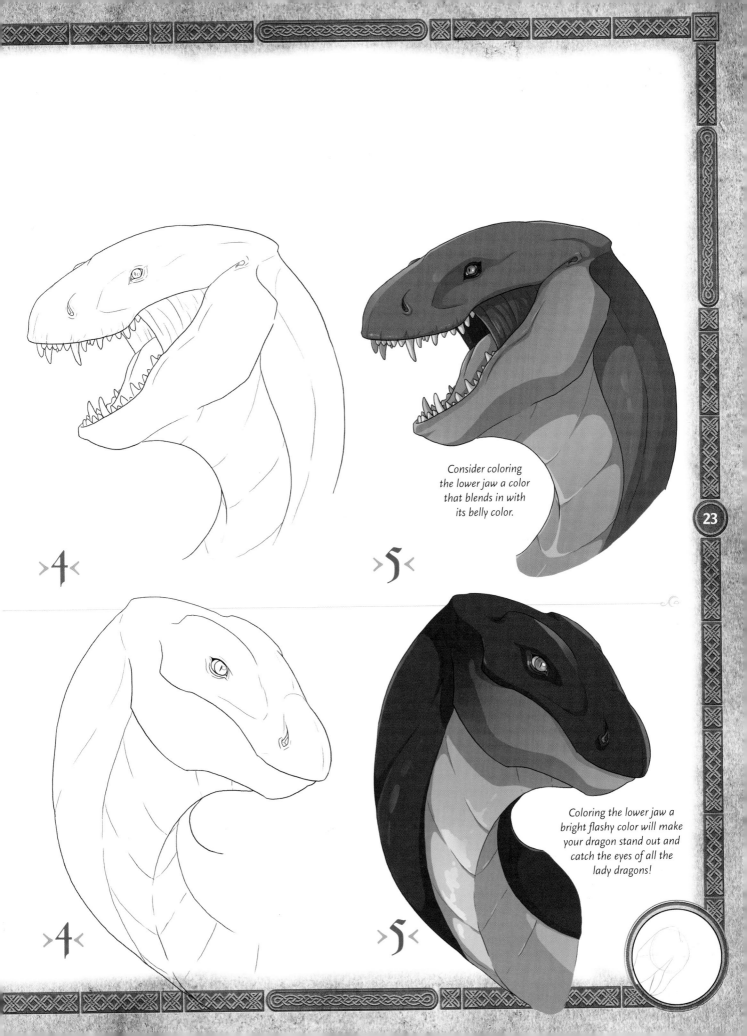

Consider coloring
the lower jaw a color
that blends in with
its belly color.

>4<

>5<

Coloring the lower jaw a
bright flashy color will make
your dragon stand out and
catch the eyes of all the
lady dragons!

>4<

>5<

23

UNDERBITE JAW

The idea behind this jaw is that the lower jaw extends well past the upper and forms a sharp, jutting chin. This can be particularly useful for dragons of a less-than-benevolent nature!

1 Draw the upper portion of the skull and jaw, and the lower jaw/mandible. The lower jaw is much thicker and longer than the upper. The larger the lower jaw, the more massive your dragon will appear.

2 Turn the jaws into a serrated blade by equipping the upper and lower portion of the jaws with sharp jutting pieces of bone and scales that extend out.

3 Pencil in a set of nostrils, high up on the skull.

4 Erase any stray construction lines and refine your drawing. (Note that this dragon is for jaw example purposes only and is lacking any embellishments.)

5 Consider coloring the upper jaw and nose a different color than the rest of the dragon.

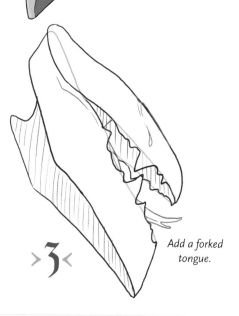

OPEN UNDERBITE

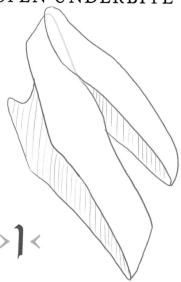

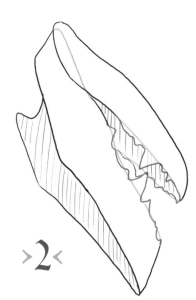

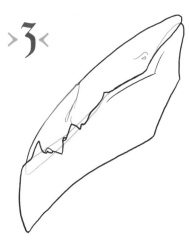

Add a forked tongue.

CLOSED UNDERBITE

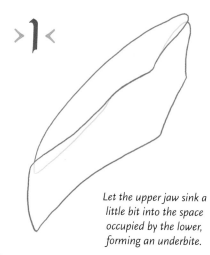

Let the upper jaw sink a little bit into the space occupied by the lower, forming an underbite.

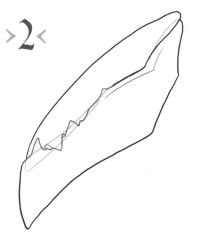

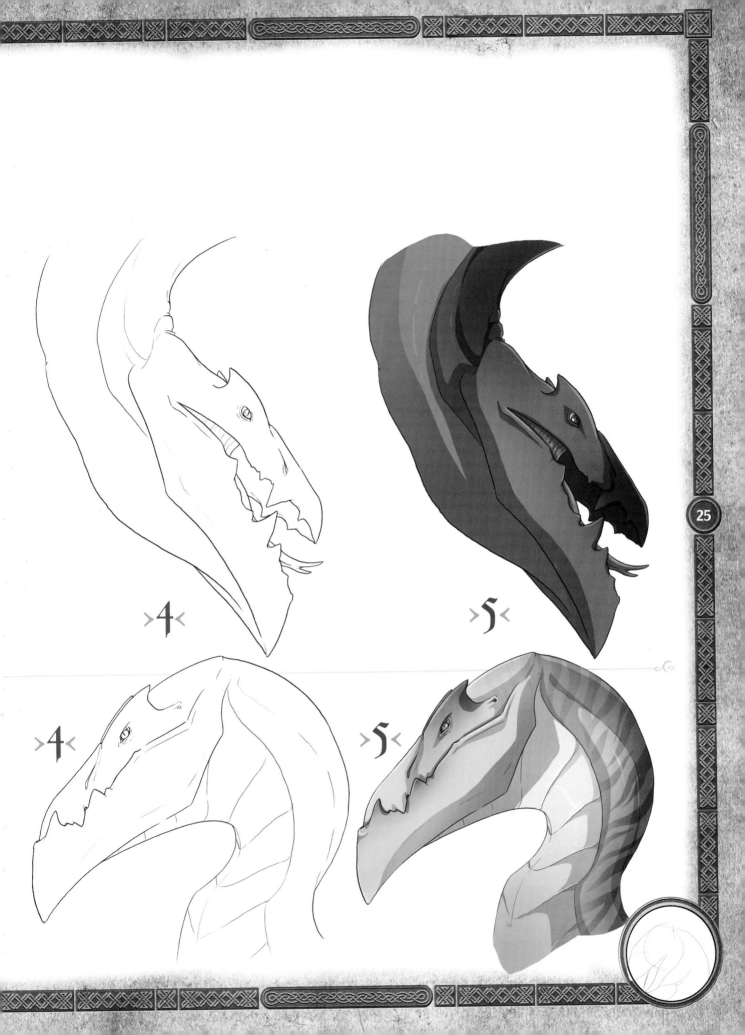

>4<

>5<

>4<

>5<

BEAK JAW

This jaw has a similar structure to that of a bird of prey. A sharp, hooked beak and lack of teeth create a regal-looking sleek-looking head.

1 Define the skull and upper and lower jaws.
2 Halfway down the head, draw the cere, the ridge in the upper portion of the beak.
3 Pencil in the nostrils or nares.
4 Erase any stray construction lines and refine your drawing.
5 Color the beaked jaw. Make the beak portion a different hue or value than the surrounding area to help it stand out.

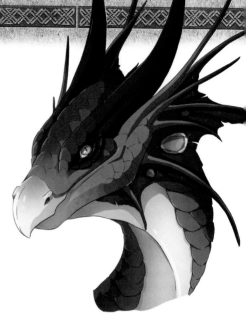

CLOSED BEAK

Make sure that the upper jaw hooks over the lower jaw.

>1<

>2<

>3<

OPEN BEAK

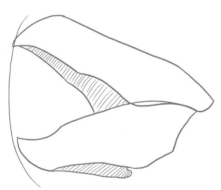

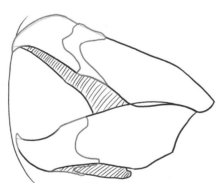

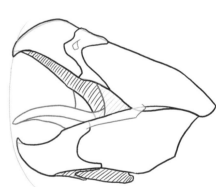

When the beak opens, make sure that the upper and lower jaw line up. A curving guideline can help with this.

Make sure that the upper and lower jaw have a hooked end to the beak.

Add a tongue.

>1<

>2<

>3<

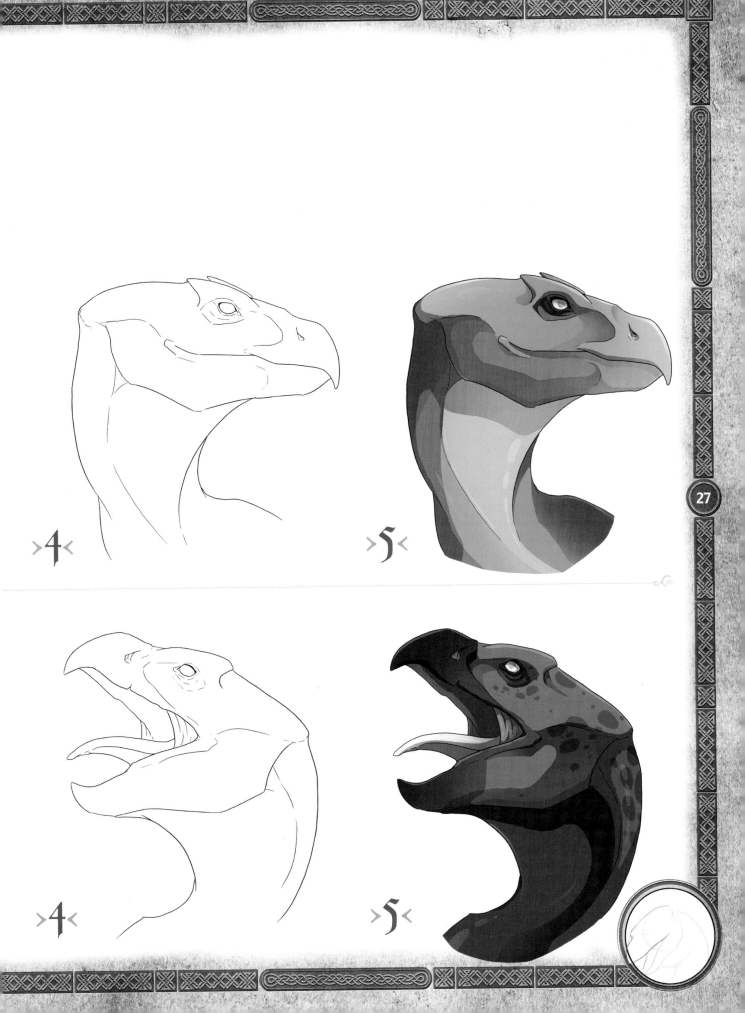

EARS

Ears can help develop the type of dragon and its expression. Ears that are laid back may show that the dragon is feeling upset or aggressive, for example. A dragon that's soft and cuddly may have tufted or feathered ears, while an aquatic dragon may have webbed ears or ear holes surrounded by elaborate fins and crests. And some dragons may not have ears at all!

FEATHERED EARS

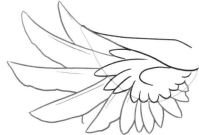

> **1** < *Pencil in a very loose ear shape that has a linear, straight top and a gently curving lobe. Add a thick rim that connects with the right side of the ear, allowing it to taper as it reaches the tip of the ear.*

> **2** < *Add a few soft, small feathers underneath the rim.*

> **3** < *A sweeping arc of stiff, large evenly spaced feathers radiates from the center of the ear.*

LONG EARS

> **1** < *Draw a long shape with a flat, stiff top and a gently-curved lobe. Draw in the ear rim, making it thicker at the base. Allow it to taper toward the tip.*

> **2** < *Add a lower rim that is thicker toward the base and tapers toward the tip. The lower rim should not be as thick as the upper. In between these two edges, place a series of U shapes in sets of two. This will create lifted areas of cartilage that will help direct sounds to him.*

> **3** < *Add details such as tufts of fur or tears along the long earlobe. Remember that any tears you make are tears into a 3-D object. The depth of each cut should reflect how thick the ear is.*

WEBBED EARS

> **1** < *Draw a round, oval shape. Add a rim that's thicker at the base and tapers toward the opposite edge.*

> **2** < *Add in a lower rim and a couple pairs of U shapes that curve towards the center of the ear.*

> **3** < *Add a series of branches that radiate out from the center. Connect these with small U-shaped pieces of webbing.*

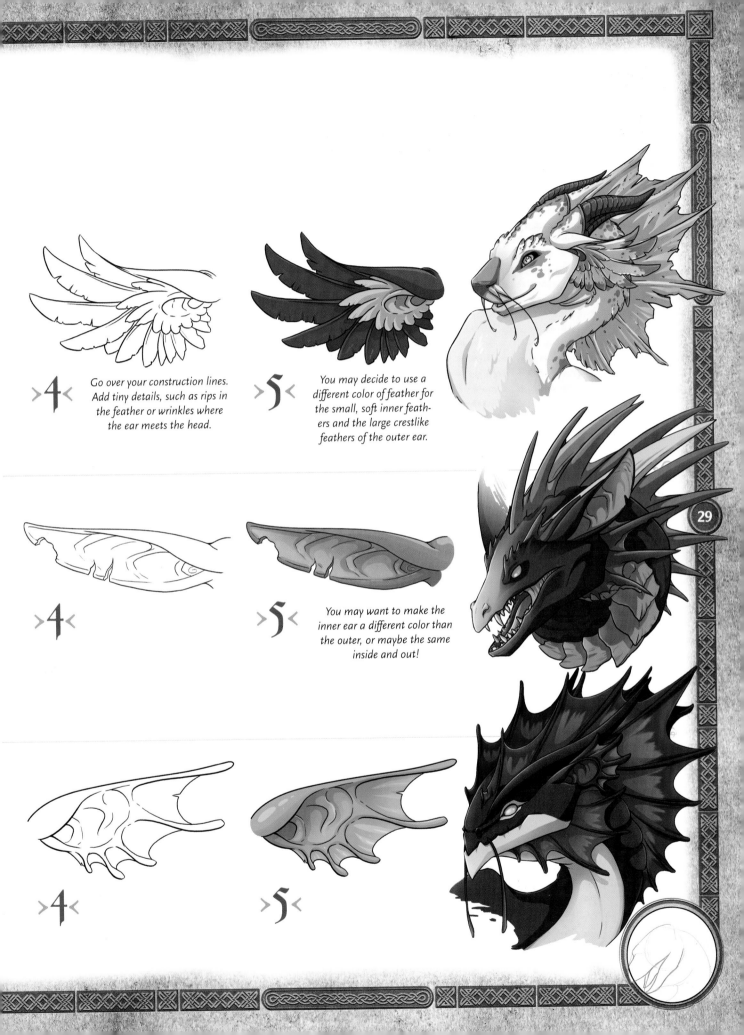

>4< Go over your construction lines. Add tiny details, such as rips in the feather or wrinkles where the ear meets the head.

>5< You may decide to use a different color of feather for the small, soft inner feathers and the large crestlike feathers of the outer ear.

>4<

>5< You may want to make the inner ear a different color than the outer, or maybe the same inside and out!

>4<

>5<

DROOPY EARS

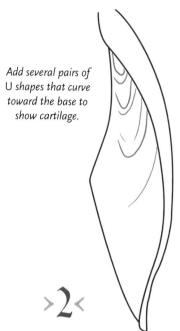

Add several pairs of U shapes that curve toward the base to show cartilage.

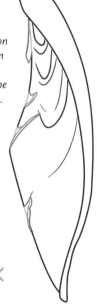

Draw in rips where your dragon may have gotten into a fight, or wrinkles where the skin hangs loose.

>1<

Draw your pencil downward to create a long, diamond shape. Add a rim that's thicker at its base and tapers toward the tip.

>2<

>3<

UPRIGHT TUFTED EARS

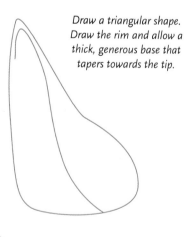

Draw a triangular shape. Draw the rim and allow a thick, generous base that tapers towards the tip.

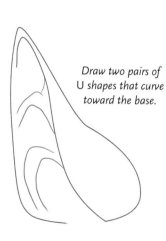

Draw two pairs of U shapes that curve toward the base.

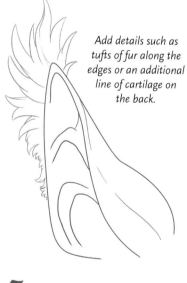

Add details such as tufts of fur along the edges or an additional line of cartilage on the back.

>1<

>2<

>3<

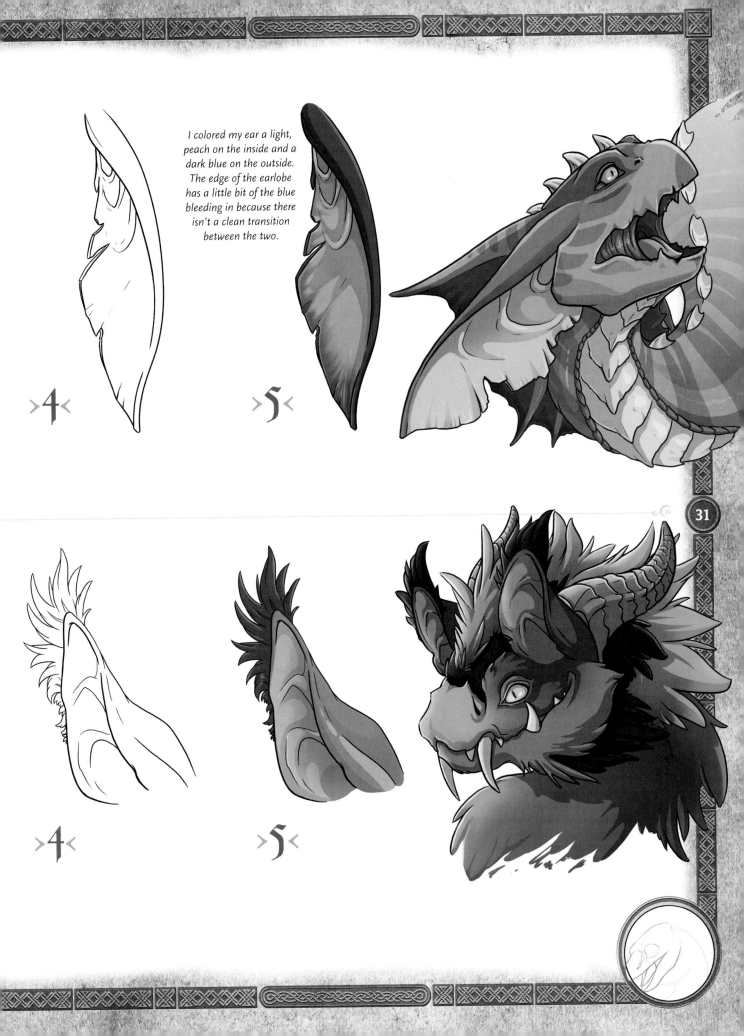

I colored my ear a light, peach on the inside and a dark blue on the outside. The edge of the earlobe has a little bit of the blue bleeding in because there isn't a clean transition between the two.

>4<

>5<

>4<

>5<

HORNS

You can create a huge variety of shapes and sizes when drawing horns, from large spirals to a series of short spikes. Do not let what's on these pages limit you. There are thousands of different horns that you can draw!

BLADED

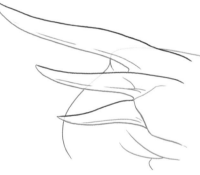

Draw a simple horn shape that curves downward.

>1<

Following the edge of the larger horn, create a series of smaller blades that taper toward the end, but also gently curve.

>2<

In the center create an interior set of scales or armor or leave it plain.

>3<

TRI

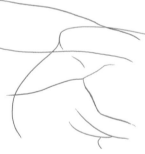

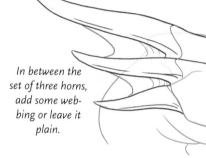

Draw a set of three lines that extends from the edge of the eye, cheek and lower jaw. Each line should have a gentle curve.

>1<

Add a lower edge to each horn that leaves the horn thick at the base and allows it to taper to a point at the end.

>2<

In between the set of three horns, add some webbing or leave it plain.

>3<

SNOUT

On the end of the snout, draw a pair of curving lines that branch out in either direction.

>1<

Add the other edge to each horn that leaves the spike thick at the base and pointed at the tip.

>2<

You can add a thin ridge of skin around where your horn meets the snout of the dragon.

>3<

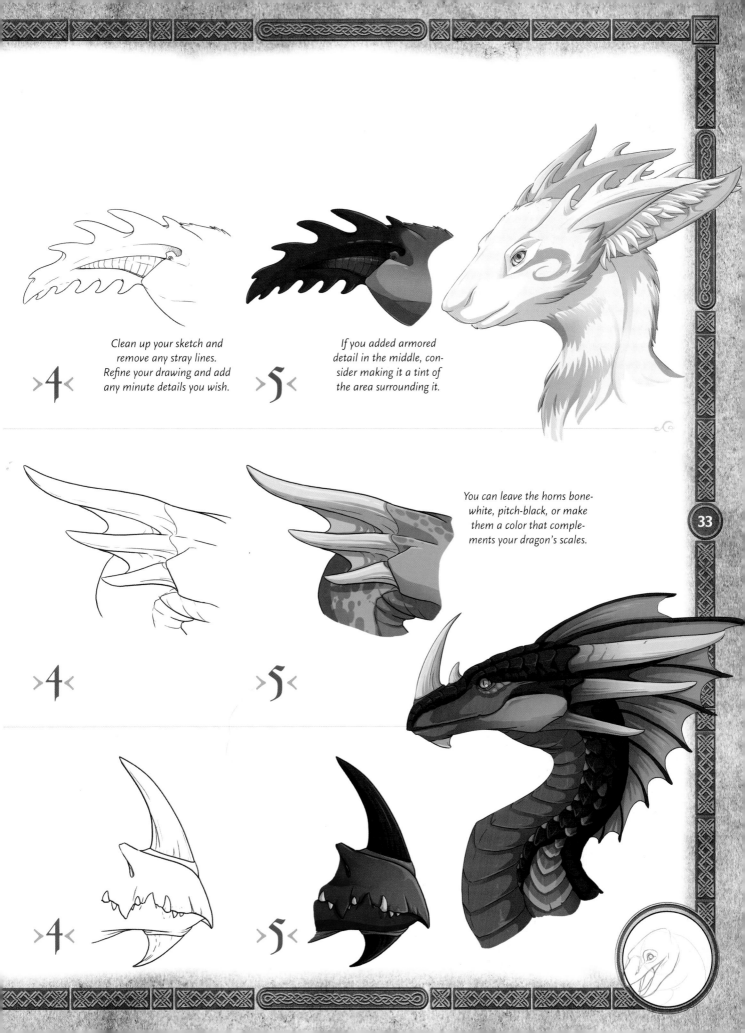

>4< Clean up your sketch and remove any stray lines. Refine your drawing and add any minute details you wish.

>5< If you added armored detail in the middle, consider making it a tint of the area surrounding it.

>4<

>5< You can leave the horns bone-white, pitch-black, or make them a color that complements your dragon's scales.

>4<

>5<

SEGMENTED

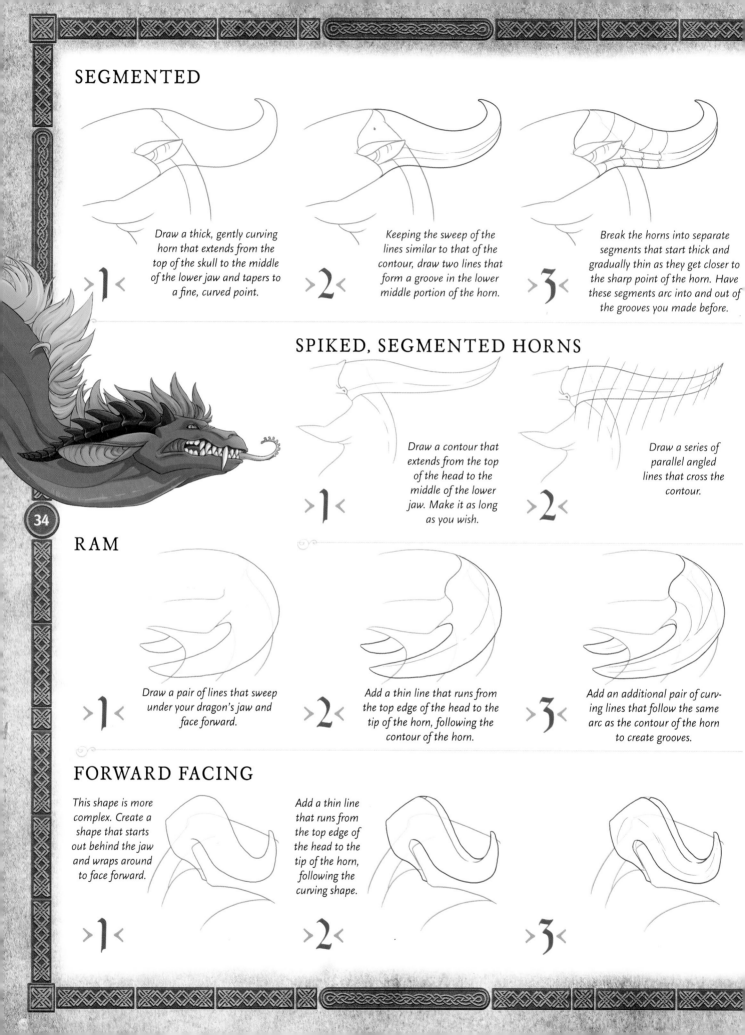

> **1**
>
> *Draw a thick, gently curving horn that extends from the top of the skull to the middle of the lower jaw and tapers to a fine, curved point.*

> **2**
>
> *Keeping the sweep of the lines similar to that of the contour, draw two lines that form a groove in the lower middle portion of the horn.*

> **3**
>
> *Break the horns into separate segments that start thick and gradually thin as they get closer to the sharp point of the horn. Have these segments arc into and out of the grooves you made before.*

SPIKED, SEGMENTED HORNS

> **1**
>
> *Draw a contour that extends from the top of the head to the middle of the lower jaw. Make it as long as you wish.*

> **2**
>
> *Draw a series of parallel angled lines that cross the contour.*

34

RAM

> **1**
>
> *Draw a pair of lines that sweep under your dragon's jaw and face forward.*

> **2**
>
> *Add a thin line that runs from the top edge of the head to the tip of the horn, following the contour of the horn.*

> **3**
>
> *Add an additional pair of curving lines that follow the same arc as the contour of the horn to create grooves.*

FORWARD FACING

This shape is more complex. Create a shape that starts out behind the jaw and wraps around to face forward.

> **1**

Add a thin line that runs from the top edge of the head to the tip of the horn, following the curving shape.

> **2**

> **3**

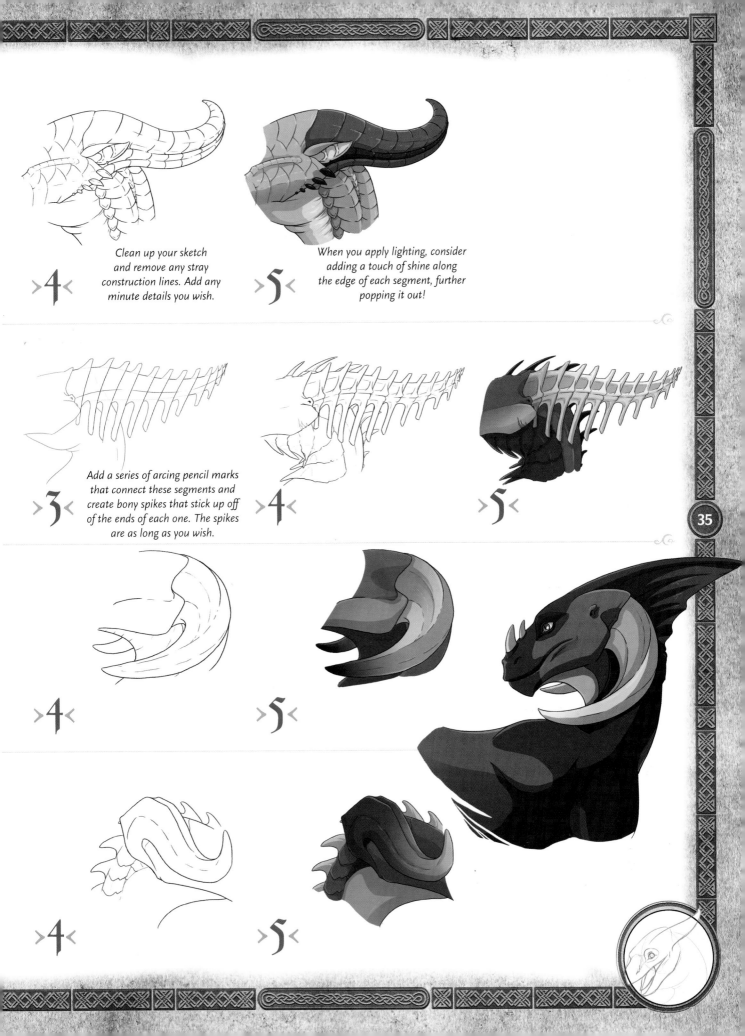

>4< Clean up your sketch and remove any stray construction lines. Add any minute details you wish.

>5< When you apply lighting, consider adding a touch of shine along the edge of each segment, further popping it out!

>3< Add a series of arcing pencil marks that connect these segments and create bony spikes that stick up off of the ends of each one. The spikes are as long as you wish.

>4<

>5<

>4<

>5<

>4<

>5<

35

DRAGON WINGS

The style of wings you choose for your dragon can contribute just as much to its overall look as the features you choose for its face. The wings will often take up a large portion of any canvas that you draw your dragon on, so having a pair with flair is important!

STANDARD BATLIKE DRAGON WING

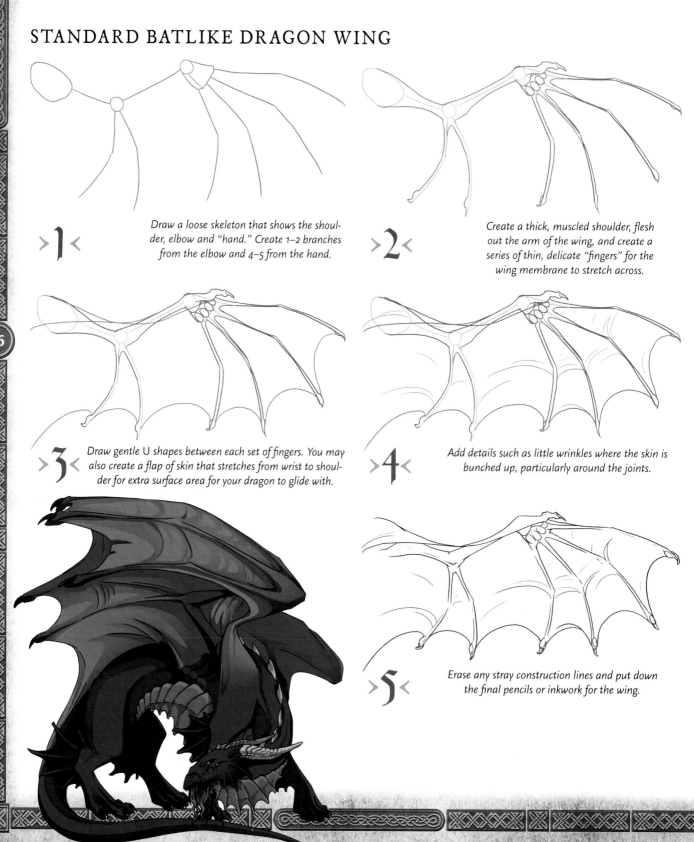

> 1 < *Draw a loose skeleton that shows the shoulder, elbow and "hand." Create 1–2 branches from the elbow and 4–5 from the hand.*

> 2 < *Create a thick, muscled shoulder, flesh out the arm of the wing, and create a series of thin, delicate "fingers" for the wing membrane to stretch across.*

> 3 < *Draw gentle U shapes between each set of fingers. You may also create a flap of skin that stretches from wrist to shoulder for extra surface area for your dragon to glide with.*

> 4 < *Add details such as little wrinkles where the skin is bunched up, particularly around the joints.*

> 5 < *Erase any stray construction lines and put down the final pencils or inkwork for the wing.*

FINGERLESS WING

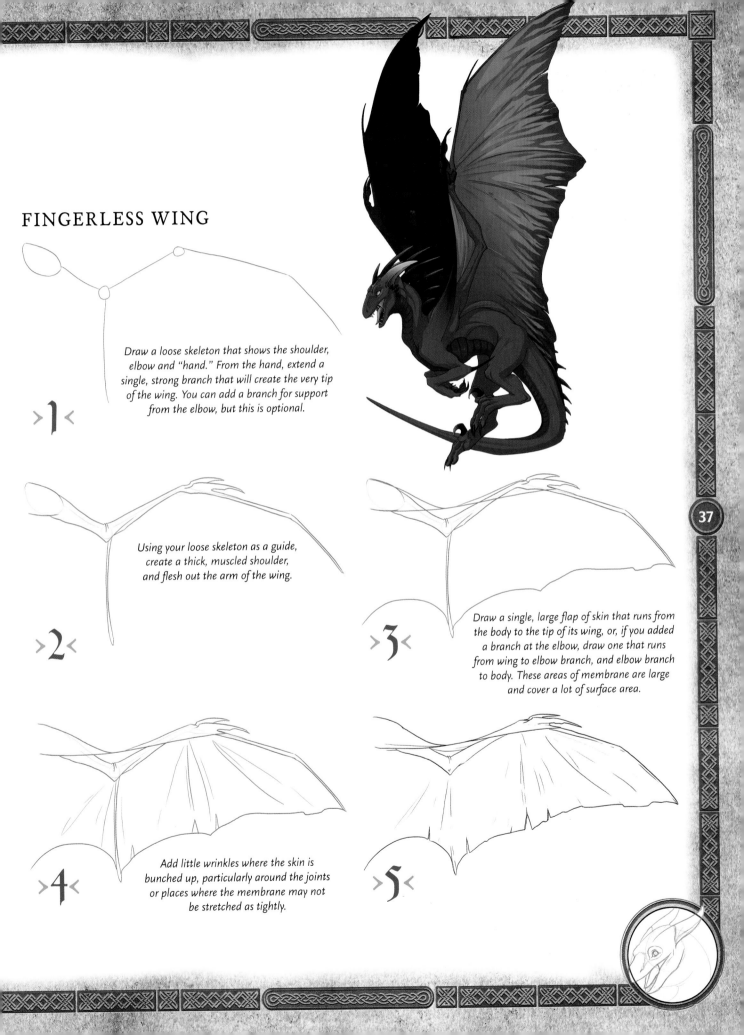

Draw a loose skeleton that shows the shoulder, elbow and "hand." From the hand, extend a single, strong branch that will create the very tip of the wing. You can add a branch for support from the elbow, but this is optional.

>1<

Using your loose skeleton as a guide, create a thick, muscled shoulder, and flesh out the arm of the wing.

>2<

Draw a single, large flap of skin that runs from the body to the tip of its wing, or, if you added a branch at the elbow, draw one that runs from wing to elbow branch, and elbow branch to body. These areas of membrane are large and cover a lot of surface area.

>3<

Add little wrinkles where the skin is bunched up, particularly around the joints or places where the membrane may not be stretched as tightly.

>4<

>5<

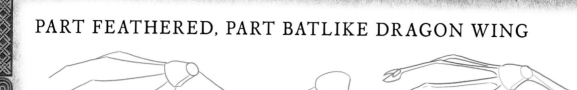

PART FEATHERED, PART BATLIKE DRAGON WING

Draw a loose skeleton that shows the shoulder, elbow and "hand." From the hand create 4–5 branches.

>1<

Create a thick, muscled shoulder, and flesh out the arm. You could add hooked claws to the end of each finger.

>2<

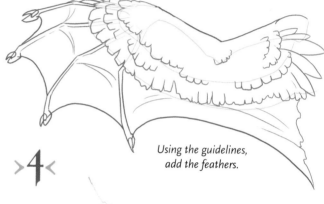

>3<

In between each pair of fingers, draw upside down, gently curving U shapes. Draw two guidelines to help you figure out where the feathers will overlap the bat wing. The feathers need to grow out of the arm portion of the wing. They cannot grow out of the thin skin of the wing membrane, as there's nothing to anchor to!

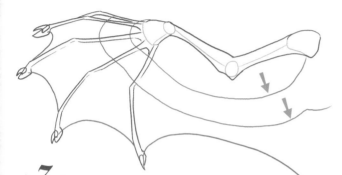

Using the guidelines, add the feathers.

>4<

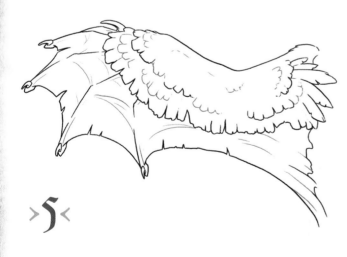

>5<

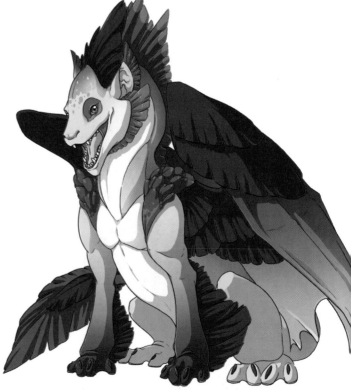

TATTERED DRAGON WING

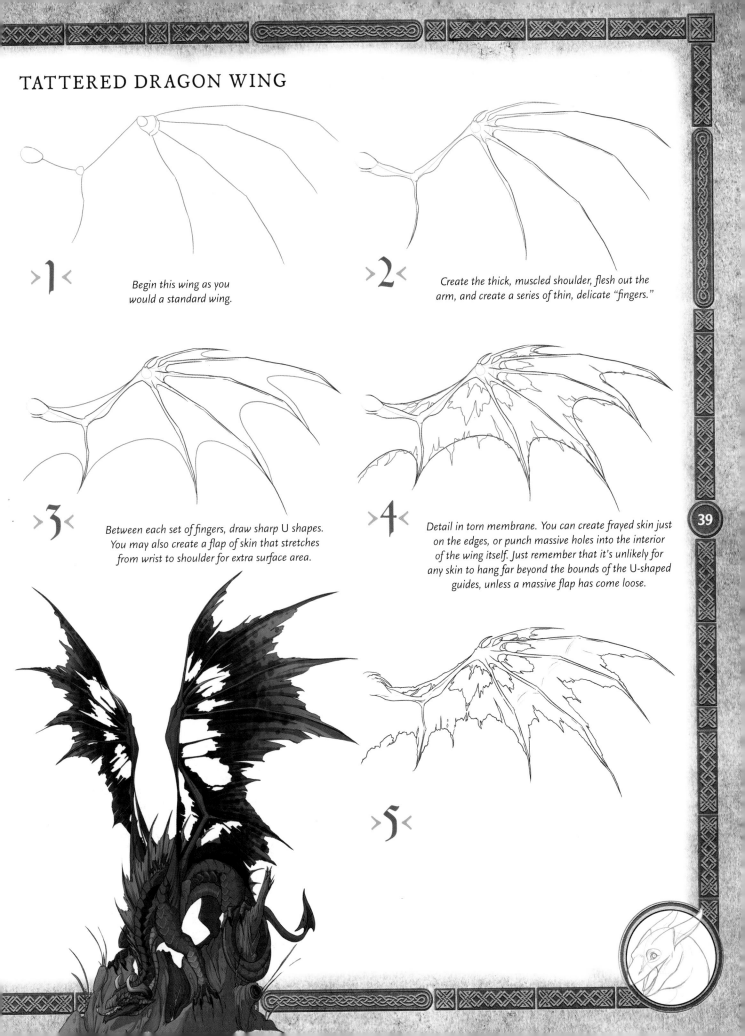

>1< *Begin this wing as you would a standard wing.*

>2< *Create the thick, muscled shoulder, flesh out the arm, and create a series of thin, delicate "fingers."*

>3< *Between each set of fingers, draw sharp U shapes. You may also create a flap of skin that stretches from wrist to shoulder for extra surface area.*

>4< *Detail in torn membrane. You can create frayed skin just on the edges, or punch massive holes into the interior of the wing itself. Just remember that it's unlikely for any skin to hang far beyond the bounds of the U-shaped guides, unless a massive flap has come loose.*

>5<

MULTISPINED DRAGON WING

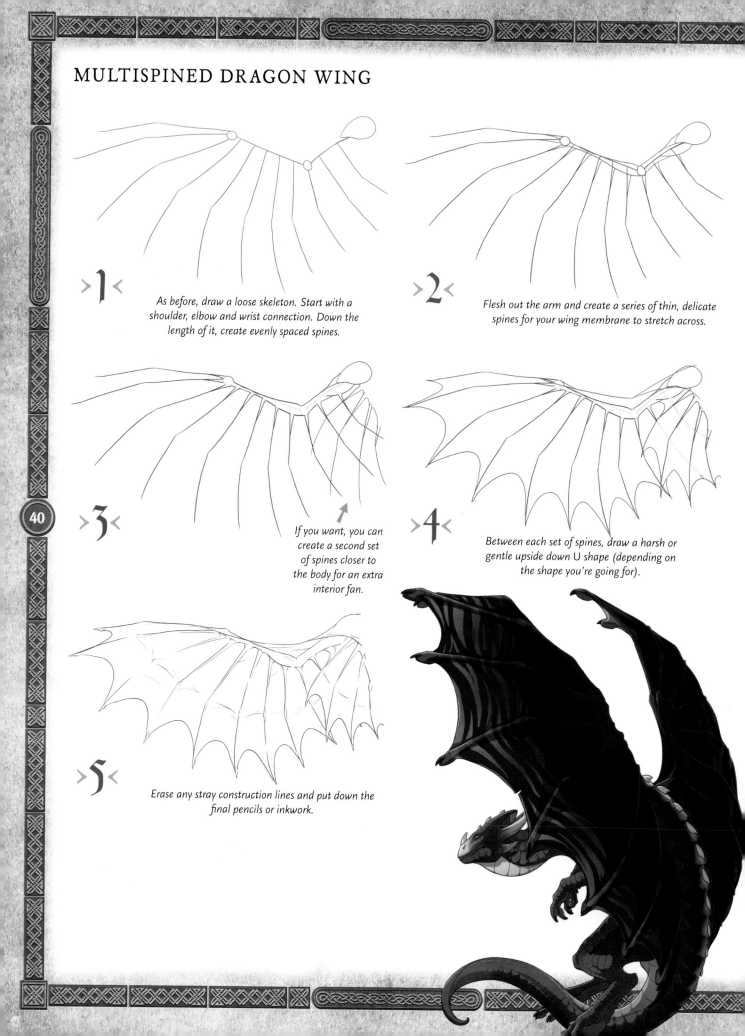

>1<

As before, draw a loose skeleton. Start with a shoulder, elbow and wrist connection. Down the length of it, create evenly spaced spines.

>2<

Flesh out the arm and create a series of thin, delicate spines for your wing membrane to stretch across.

>3<

If you want, you can create a second set of spines closer to the body for an extra interior fan.

>4<

Between each set of spines, draw a harsh or gentle upside down U shape (depending on the shape you're going for).

>5<

Erase any stray construction lines and put down the final pencils or inkwork.

SCALES

Many dragons are based on the idea of a large flying reptile, so a scaled hide can be just as appropriate as a leather hide. Putting scales and plating on your dragons allows for further design customization, and the type of scales you use affects the final look. You can use scales all of the same type or combine many different types of scale for an elaborate pattern. When putting scales—or any details—on your dragon, plan in advance what type of look you're going for.

Scales (and all things associated with dragon kind) are awesome. You must learn to harness this awesome and use it wisely.

Choosing the right time to draw the details is important.

The dragon that's in the foreground or is the main focus of the image can easily have every wrinkle and scale drawn carefully in.

While a dragon that is smaller or in the background may become overly cluttered given the same level of detail.

41

SCALE PATTERN 1
This pattern is based around a series of half ovals.

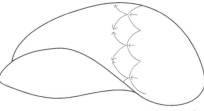

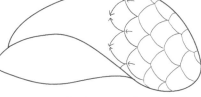

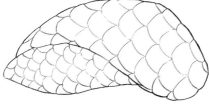

>1< *The bottom of each oval is where the next row of ovals begins.*

>2< *Continue wrapping the pattern around the body and limbs.*

>3< *Create bumps and indentations along the edges of your initial shapes for a 3-D feel.*

Place small shadows at the points where two scales meet. Scales are small, relatively flat objects, so they won't cast huge shadows. If you shade them too much, your dragon may end up looking like one big flat pattern. Light the body as a whole before you create shadows for the details.

>4<

SCALE PATTERN 2

This pattern is created with polygons.

>1< Start with a hexagon. Each edge shares with another scale. Each corner is the point at which you can create a new line, thus a new edge for the scales that follow to share.

>2< The key to this pattern is that every scale shares a side with the scale next to it, and that all the corners are shared as well.

>3< Create dips and bumps along the edges of the body parts you were covering with scales so that the scales seem more 3-D.

SCALE PATTERN 3

This flat scale pattern requires a touch of preplanning.

 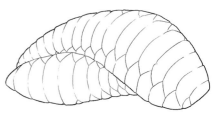

>1< Create two guidelines located between each row of scales. Once these are in place, curve a series of lines around the shapes creating the rows of scales.

>2< The small space you created the guides for will be used to finish off the edge of each scale. Link each scale to the corner of another above it on the opposing side. This makes the scales interlock.

>3< Erase the guidelines and clean up your scale pattern.

SCALE PATTERN 4

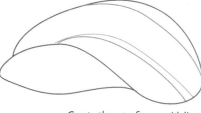 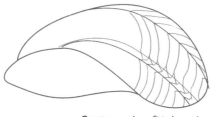 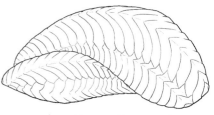

>1< Create the set of two guidelines between each row of scales. Put a guide down the center of each row.

>2< Create a series of V-shaped scales. Draw the guideline down the center of each row so that the point of each V lines up and follows the form of the dragon's body. Use the guides in between each row of V-shaped scales to interlock the scales. Draw a line that extends from the edge of each scale and connects to the edge of the scale above it on the adjacent row.

>3< You can either erase the guideline used to create the point of each V or leave it in place or break it up to make it appear as if there's a ridge down the center of each V.

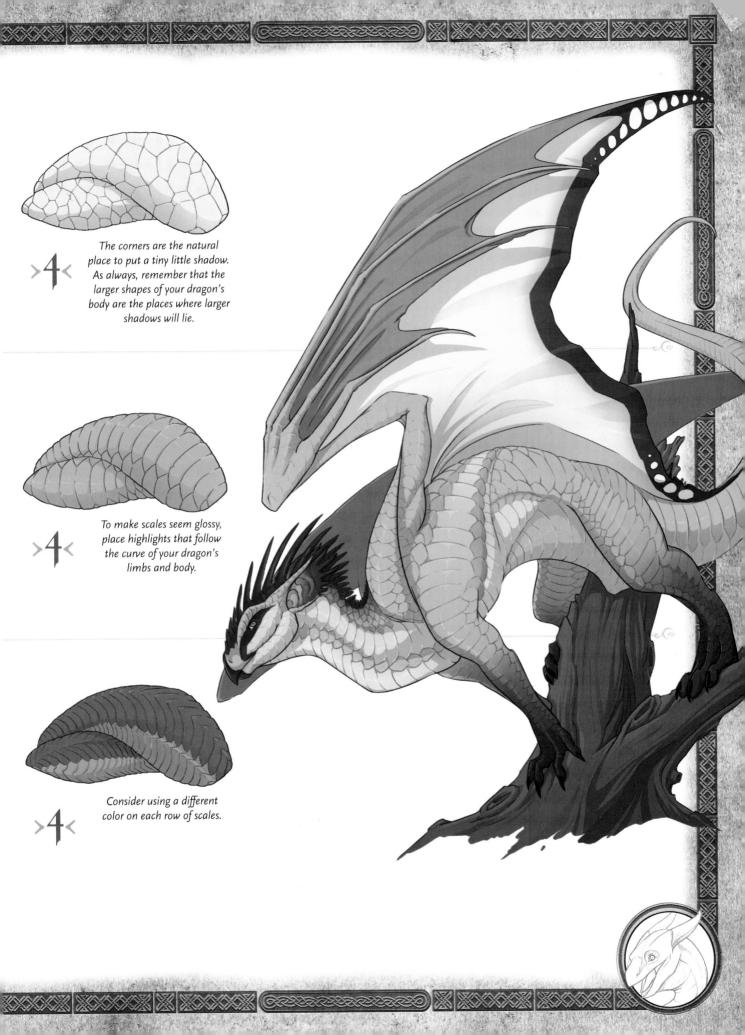

>4<
The corners are the natural place to put a tiny little shadow. As always, remember that the larger shapes of your dragon's body are the places where larger shadows will lie.

>4<
To make scales seem glossy, place highlights that follow the curve of your dragon's limbs and body.

>4<
Consider using a different color on each row of scales.

SCALE PATTERN 5

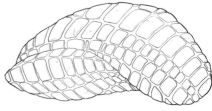

>1< Lay down a series of guides that will dictate the rows where each of the scales and the spaces in between them will be.

>2< Staying in the guides of each row, create rectangular scales spaced as roughly far apart as the rows are spaced from each other.

>3< Clean up the guidelines and you're left with neat little rows of rectangular, bumpy scales that sit on top of the dragon's hide.

SCALE PATTERN 6

Some dragons have an underbelly that's different than the rest of their hide, so you'll need a series of flat glossy scales for the belly.

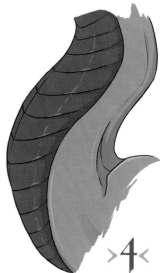

>1< Lay down a guideline to dictate the edge where the belly meets the rest of the skin covering him. Add another guide that will run down the center of the belly.

>2< Keeping your scales within the edges of the underbelly, create a series of horizontal curves. The point at which each curve turns upward should meet at the guideline running down the center of the belly.

>3< Clean up your scales.

>4< The underbelly may be a different color than the rest of the dragon's body.

>4<
You can make the scales glossy, and the leathery hide beneath a duller finish.

SCALE PATTERN 7

>1<
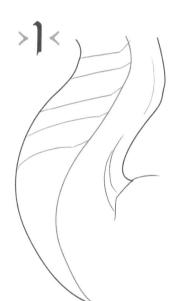

>2<
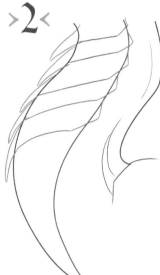

>3<
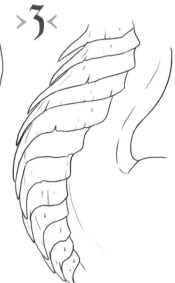

>4<
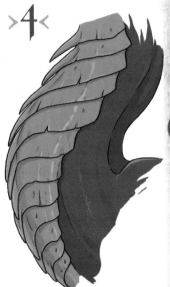

Create a series of flat horizontal scales that follow the line of the dragon's belly.

Extend the V and edge of each scale to create over-sized plates that overlap each other as well as the skin beneath them.

Erase the unnecessary lines. Consider adding nicks and dings to the scale plating.

As these scales are larger and overlap more than flatter interlocking scales, they may create slightly more prominent shadows.

DRAGON LIMBS

Making sure that your dragon's limbs have good proportions, skeletal structure and musculature will help ensure that believability. (Legs need to capable of bearing dragon weight.) Also keep in mind when coloring that most often dragon limbs are the same color as the rest of the body.

LEGS

Let's kick off this unit with a basic leg.

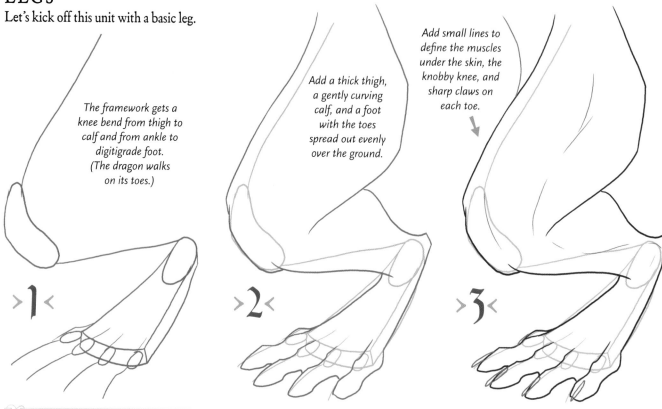

The framework gets a knee bend from thigh to calf and from ankle to digitigrade foot. (The dragon walks on its toes.)

Add a thick thigh, a gently curving calf, and a foot with the toes spread out evenly over the ground.

Add small lines to define the muscles under the skin, the knobby knee, and sharp claws on each toe.

>1< >2< >3<

46

ARMS

Now let's do a simple arm with an opposable thumb, much like our own.

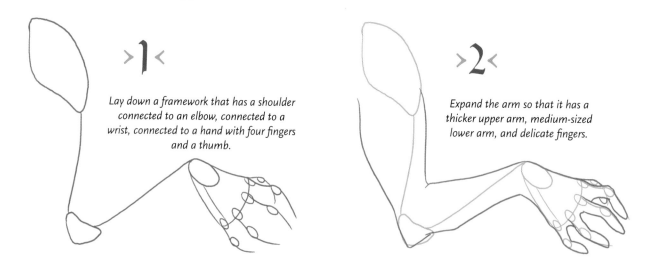

>1<

Lay down a framework that has a shoulder connected to an elbow, connected to a wrist, connected to a hand with four fingers and a thumb.

>2<

Expand the arm so that it has a thicker upper arm, medium-sized lower arm, and delicate fingers.

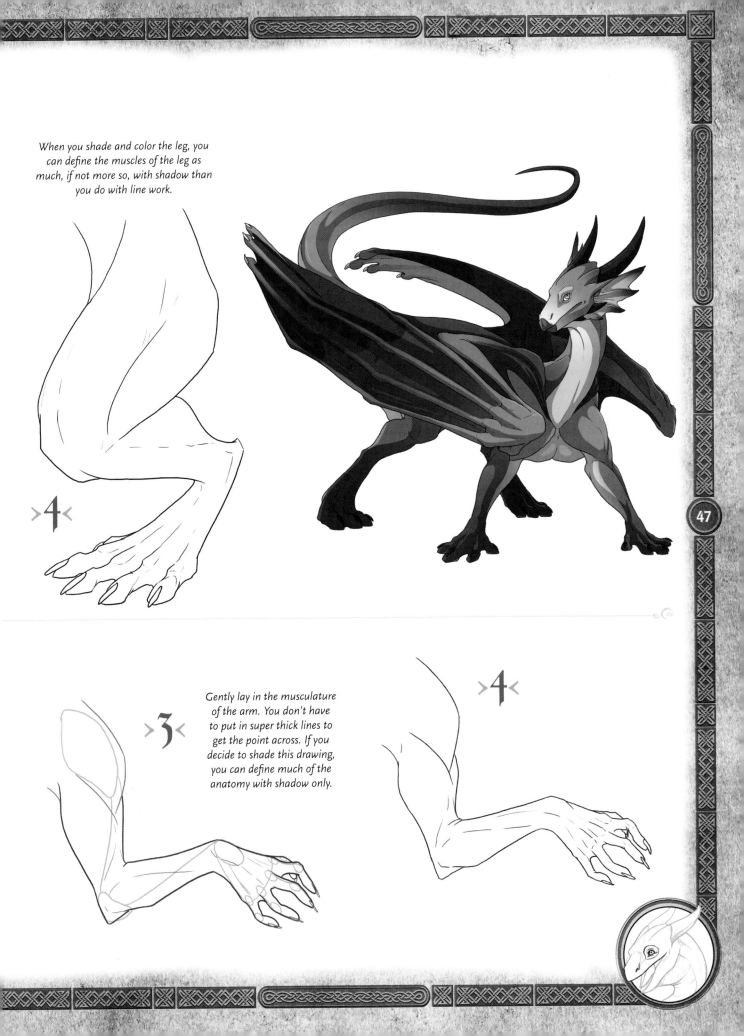

When you shade and color the leg, you can define the muscles of the leg as much, if not more so, with shadow than you do with line work.

>4<

Gently lay in the musculature of the arm. You don't have to put in super thick lines to get the point across. If you decide to shade this drawing, you can define much of the anatomy with shadow only.

>3<

>4<

BIPED LEGS

The idea behind this set is that the dragon walks upright on two legs, much like a T-rex or Velociraptor. Often, these have thick, stiff, upright tails to help balance them.

Lay in a basic framework for long, powerful back legs.

Lightly add the musculature and the knuckles and bones of the feet.

BIPED ARMS

The arms are likely held close to the body while he runs. They're not load bearing, and so are thinner and smaller than the hind limbs.

Add gentle curves along the upper arm and wrinkles of fat, muscle and connective tissue where the arm meets the body.

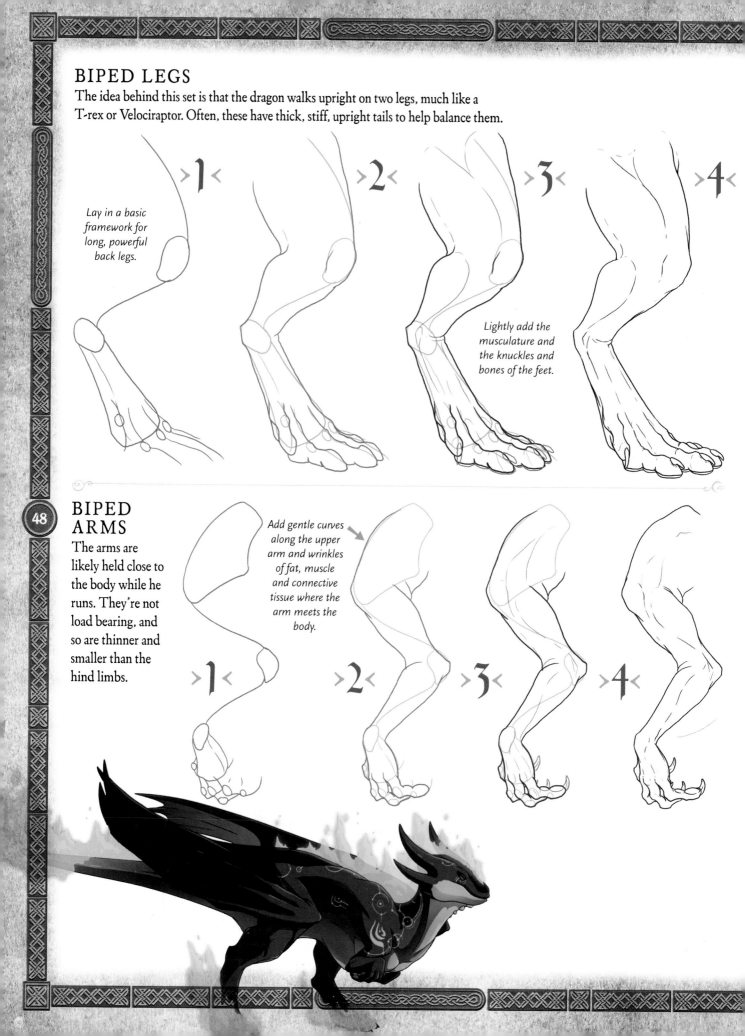

STUBBY LEGS

Shorter, squatter limbs are suitable for a heavy dragon that walks with his body lower to the ground.

The thigh and calf may be thicker than those of the average dragon.

Lightly pencil in the musculature and add fine details like the claws and the edges of the paw pads peeking out.

>1<

>2<

The toes may be shorter than average.

>3<

>4<

STUBBY ARMS

The arms on this sort of dragon often look a lot like the legs.

Remember to include a meaty bicep for this arm.

>1<

>2<

>3<

>4<

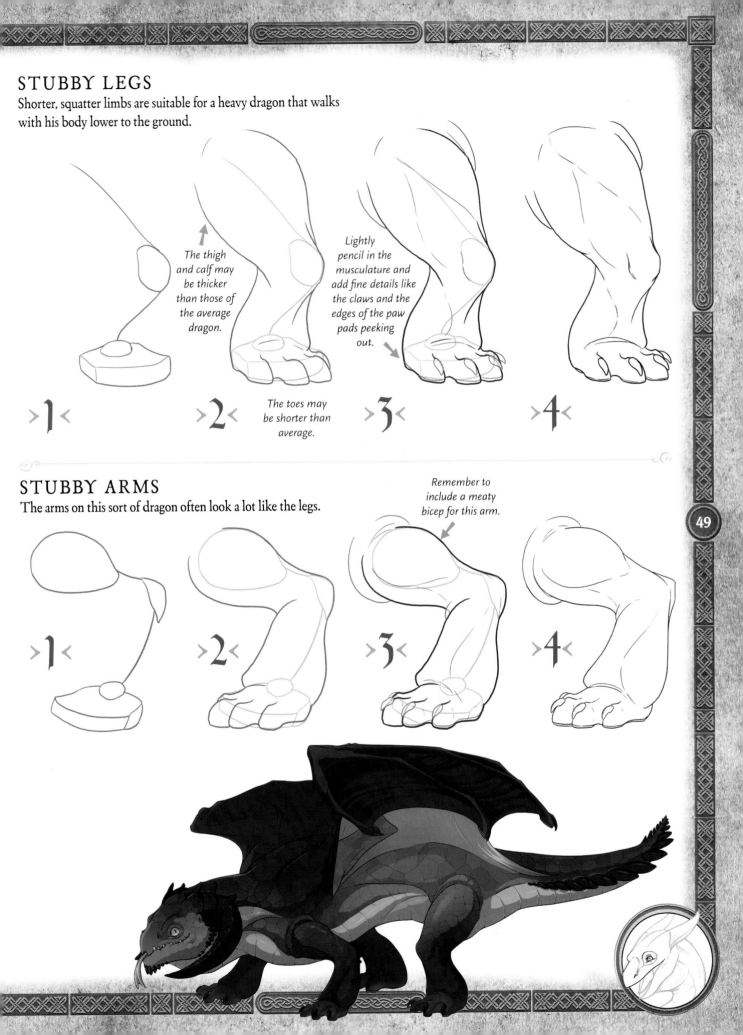

DELICATE LEGS

The opposite of the stubby legs, these limbs are elongated and thin. They are meant for supporting a smaller, lighter dragon who spends more time in the air than on the ground.

>1< >2< >3< >4<

The leg may not be as thick as those of other dragons.

Make these claws longer than on previous legs.

DELICATE ARMS

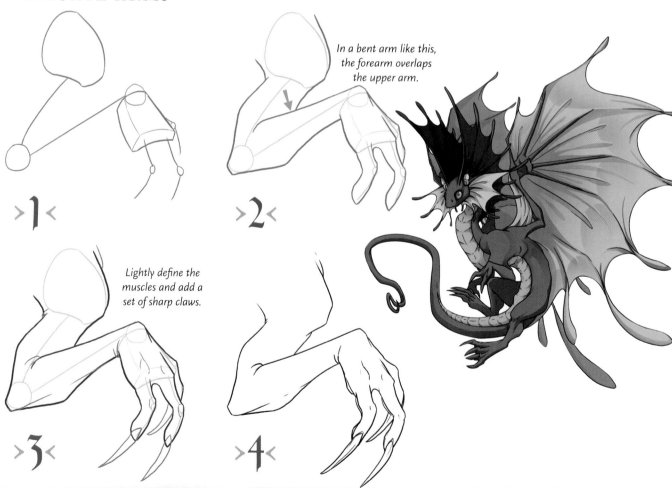

>1<

In a bent arm like this, the forearm overlaps the upper arm.

>2<

Lightly define the muscles and add a set of sharp claws.

>3<

>4<

FURRED LEGS

For our purposes we'll add feathering/fur to a quadruped dragon. Keep in mind a dragon's fur may be a different color than the skin underneath, so you can have a little fun!

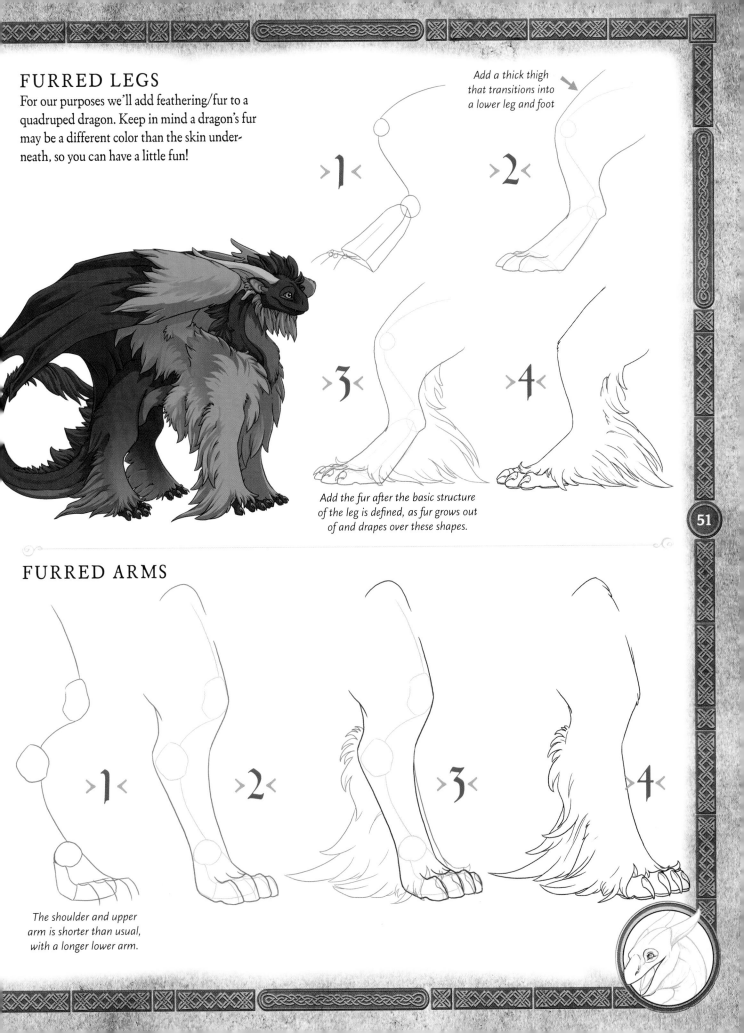

Add a thick thigh that transitions into a lower leg and foot

>1<

>2<

>3<

>4<

Add the fur after the basic structure of the leg is defined, as fur grows out of and drapes over these shapes.

FURRED ARMS

>1<

>2<

>3<

>4<

The shoulder and upper arm is shorter than usual, with a longer lower arm.

DRAGON BRIDLES AND SADDLES

Dragon riding can be a tricky business since your mount can do a complete 180 and down, down, down you go! To avoid this problem, a secure saddle or harness is a very good idea as is a good bridle. Remember that you're dealing with wings, horns and legs when designing dragon gear. Here are some ideas.

SIMPLE BRIDLE

This is just like a horse bridle.

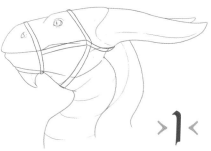

>1<

Draw the straps of leather around the head. The leather curves around the head, which is a three-dimensional object.

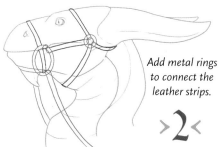

Add metal rings to connect the leather strips.

>2<

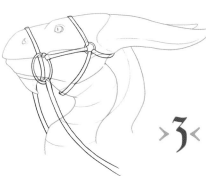

>3<

NECK HARNESS

This leaves the dragon's mouth free so he can bite and breathe fire. The rider can tug on rings to guide him.

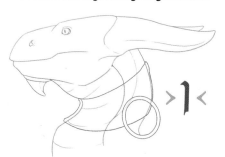

>1<

Draw a thick band around the neck, and a metal ring to either side

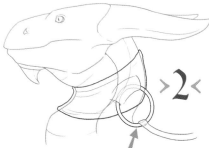

>2<

Make sure that the metal ring pierces the leather or material of the neck harness. It may create a bump when it does so, instead of magically disappearing inside.

>3<

ARMORED HEADGEAR

If your rider is using a fighting dragon, armor for his mount may be an good idea!

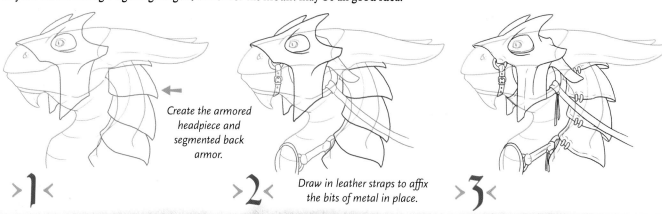

Create the armored headpiece and segmented back armor.

>1<

>2<

Draw in leather straps to affix the bits of metal in place.

>3<

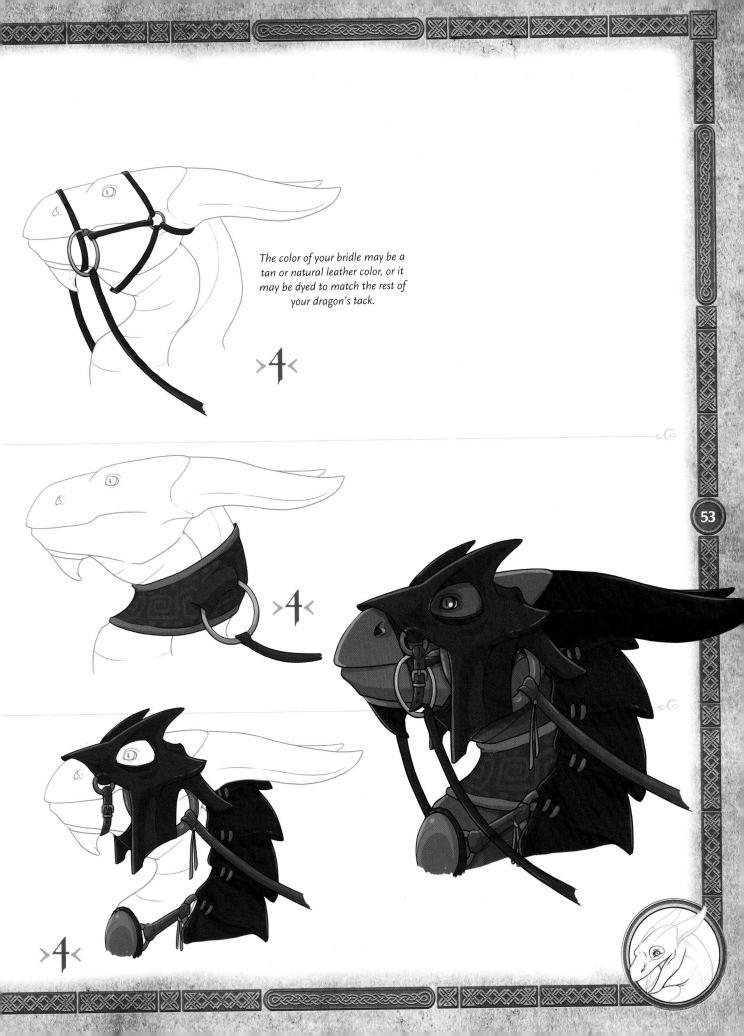

The color of your bridle may be a tan or natural leather color, or it may be dyed to match the rest of your dragon's tack.

>4<

>4<

>4<

SADDLE 1

Resting the saddle on the neck and shoulder instead of the back helps keep it in front of the wings so your rider isn't battered.

>1< *Create two padded pieces of leather that rest on the shoulders, just before the wings.*

>2< *Add two leather straps that wrap around the front legs, creating a sort of dragon backpack.*

>3< *Add details such as strap adjustments and raised edges to the molded leather.*

SADDLE 2

This one is really more of a handhold and place to tie a safety strap. With this, your rider lays across the back between the wings and holds on for dear life.

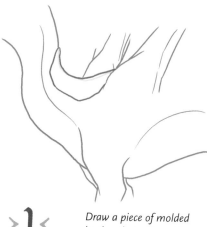 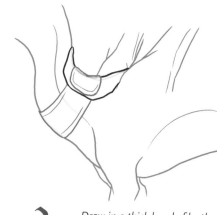

>1< *Draw a piece of molded leather that rests on the neck and shoulder.*

>2< *Draw in a thick band of leather that wraps completely around your dragon's neck, securing the saddle in place.*

SADDLE 3

For a saddle that rests on the dragon's back and doesn't involve a complex series of straps, pierce the wing. This causes air to escape through if you make the hole too large and is slightly unrealistic, but we are talking about dragons here.

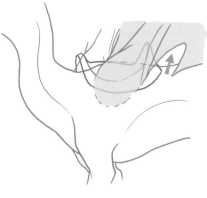 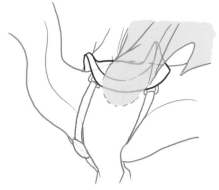

>1<

>2< *Draw four straps (two on each side) that connect to a central piece positioned on the chest.*

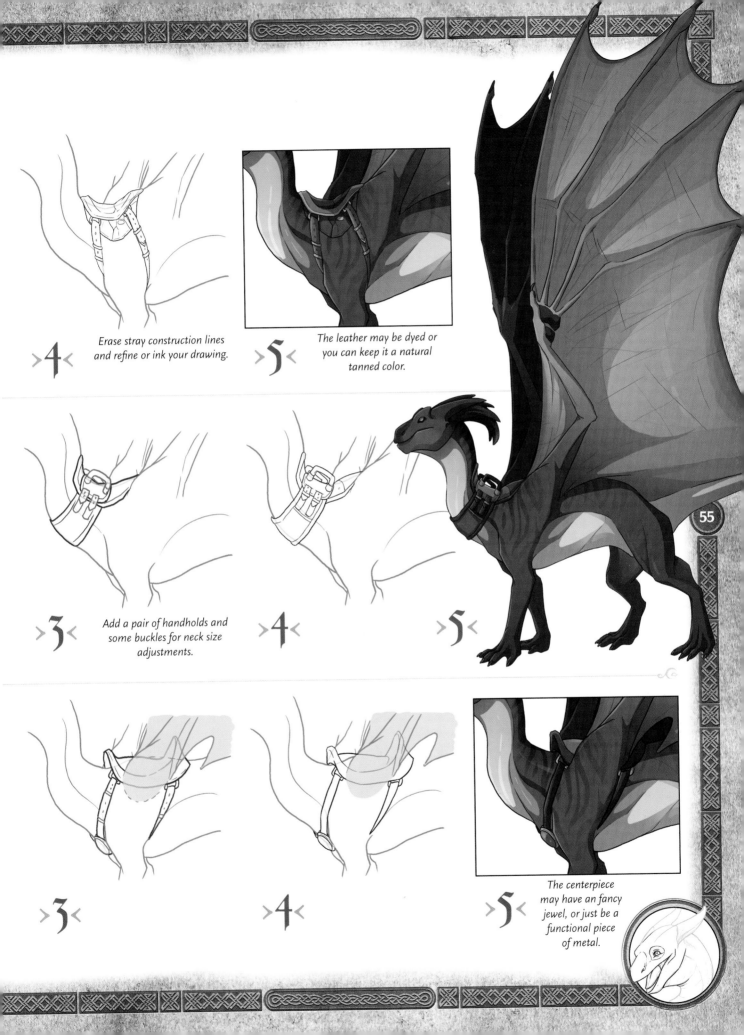

>4< Erase stray construction lines and refine or ink your drawing.

>5< The leather may be dyed or you can keep it a natural tanned color.

>3< Add a pair of handholds and some buckles for neck size adjustments.

>4<

>5<

55

>3<

>4<

>5< The centerpiece may have an fancy jewel, or just be a functional piece of metal.

> PART 2 <
DRAGON DEMONSTRATIONS

Now that you've had a chance to practice some of the pieces of anatomy and details, it's time to put what you've learned into practice and draw some complete dragons! Making the dragon a seamless whole is very important and will make your drawings much more believable. Let's begin drawing dragons with origins from all around the world and the imagination.

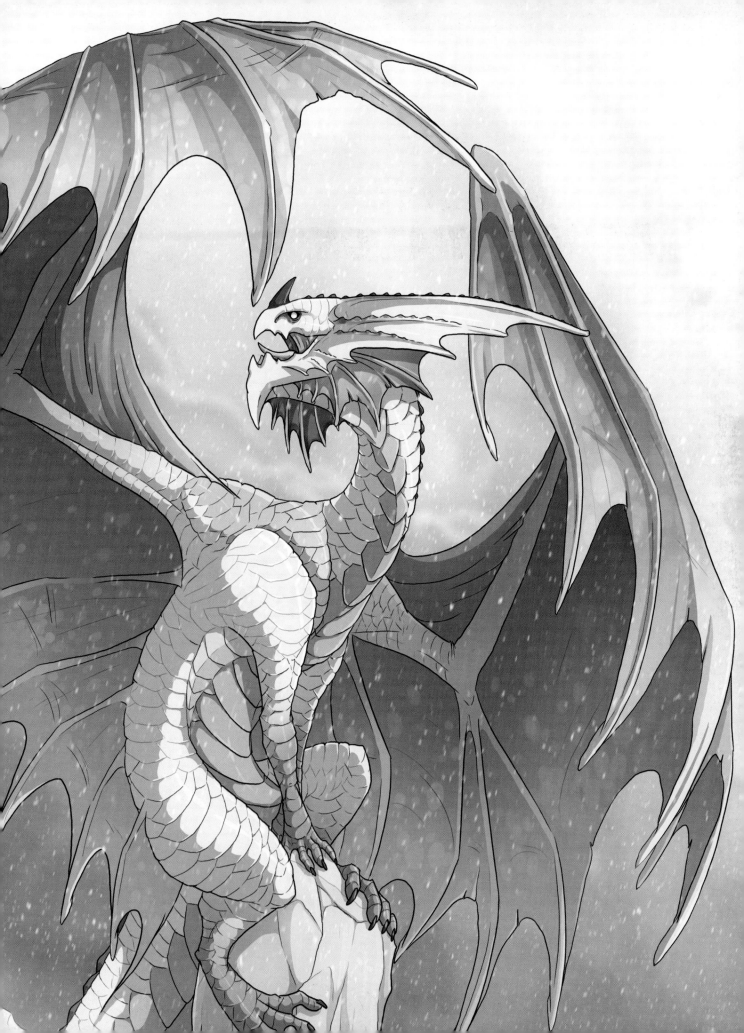

DRAGON HEAD SHAPES

Dragons can be many different shapes and sizes. It's important to consider the look of the dragon that you are creating when you design its head. Do you want your dragon to look enormous and ancient? Consider a strong jaw, and small eyes to convey its size, while broken scales and fractured horns can convey the age of the beast. Looking for something a bit sleeker? A long jaw, smooth leathery skin, and fancy frills might be just what you were looking for!

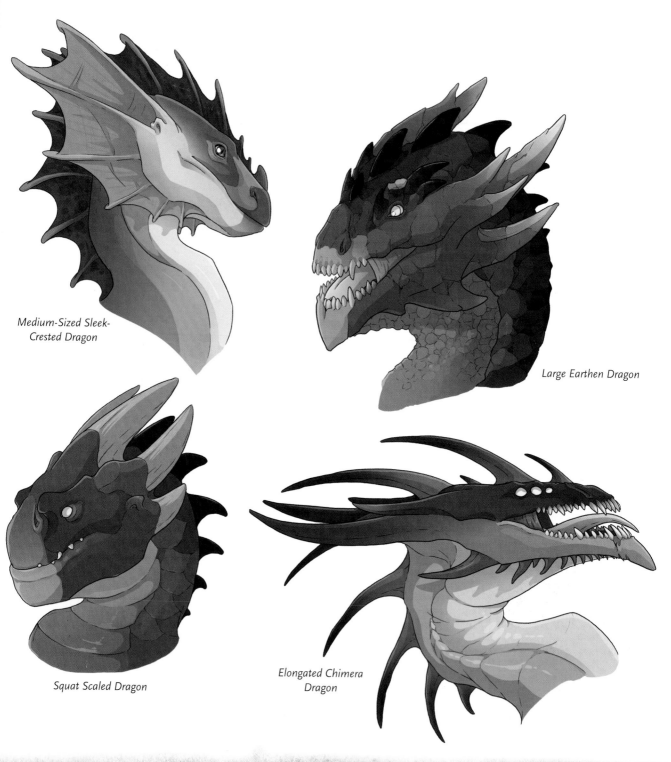

Medium-Sized Sleek-Crested Dragon

Large Earthen Dragon

Squat Scaled Dragon

Elongated Chimera Dragon

DRAGON EXPRESSIONS

In day-to-day life, you don't sit around with the same expression plastered on your face and neither does your dragon. He might be looking pleased with himself over a new piece of treasure he's recently acquired. Perhaps he's afraid of the shadows or another larger dragon that has crossed his path. A child pulling on his tail might annoy him or make him hungry. How your dragon is feeling can be conveyed through his body language and facial expression. Use both to convey the point and tell a good story.

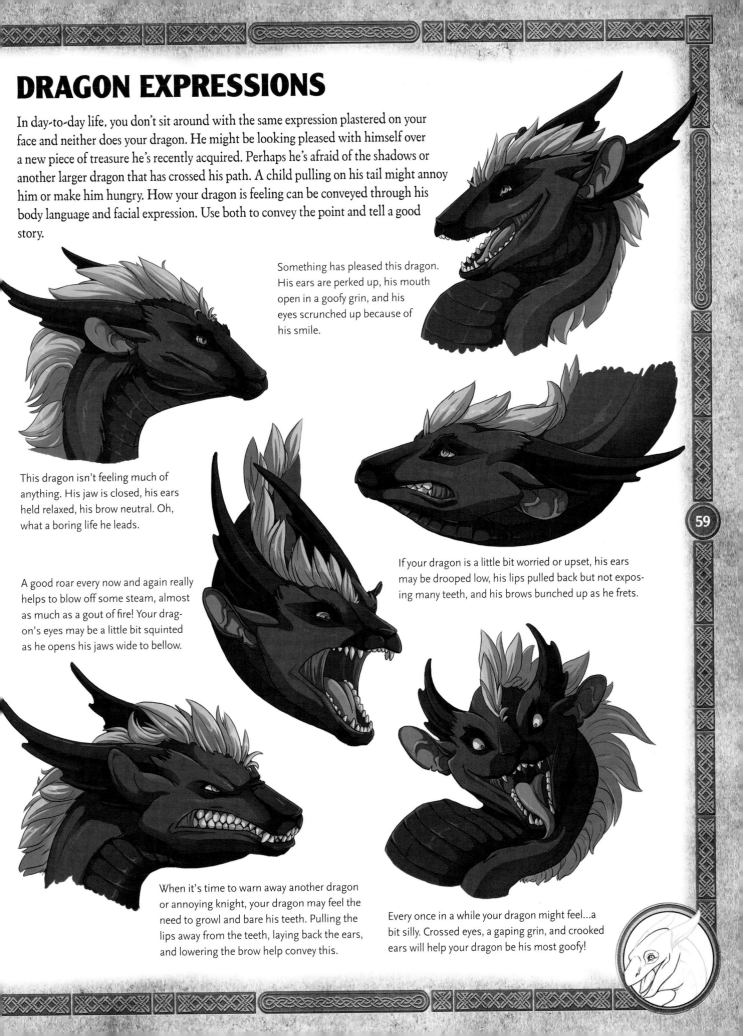

Something has pleased this dragon. His ears are perked up, his mouth open in a goofy grin, and his eyes scrunched up because of his smile.

This dragon isn't feeling much of anything. His jaw is closed, his ears held relaxed, his brow neutral. Oh, what a boring life he leads.

A good roar every now and again really helps to blow off some steam, almost as much as a gout of fire! Your dragon's eyes may be a little bit squinted as he opens his jaws wide to bellow.

If your dragon is a little bit worried or upset, his ears may be drooped low, his lips pulled back but not exposing many teeth, and his brows bunched up as he frets.

When it's time to warn away another dragon or annoying knight, your dragon may feel the need to growl and bare his teeth. Pulling the lips away from the teeth, laying back the ears, and lowering the brow help convey this.

Every once in a while your dragon might feel...a bit silly. Crossed eyes, a gaping grin, and crooked ears will help your dragon be his most goofy!

59

MEDIEVAL DRAGON

Dragons in European folklore were not typically portrayed as benevolent creatures. These were monsters—creatures that lurked in the mysterious unknown places of the world. These serpentine reptiles could have two legs, four legs, wings or no limbs at all! They breathed fire, had a venomous bite and loved to guard treasure. In recent times, Western dragons have been featured more frequently in literature, movies and games. The most common appearance of a Western dragon is a quadruped with bat-like wings, a long scaly tail and the ability to breathe gouts of flame.

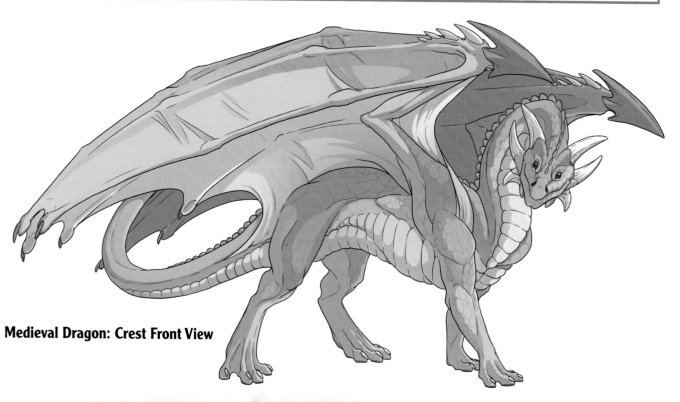

Medieval Dragon: Crest Front View

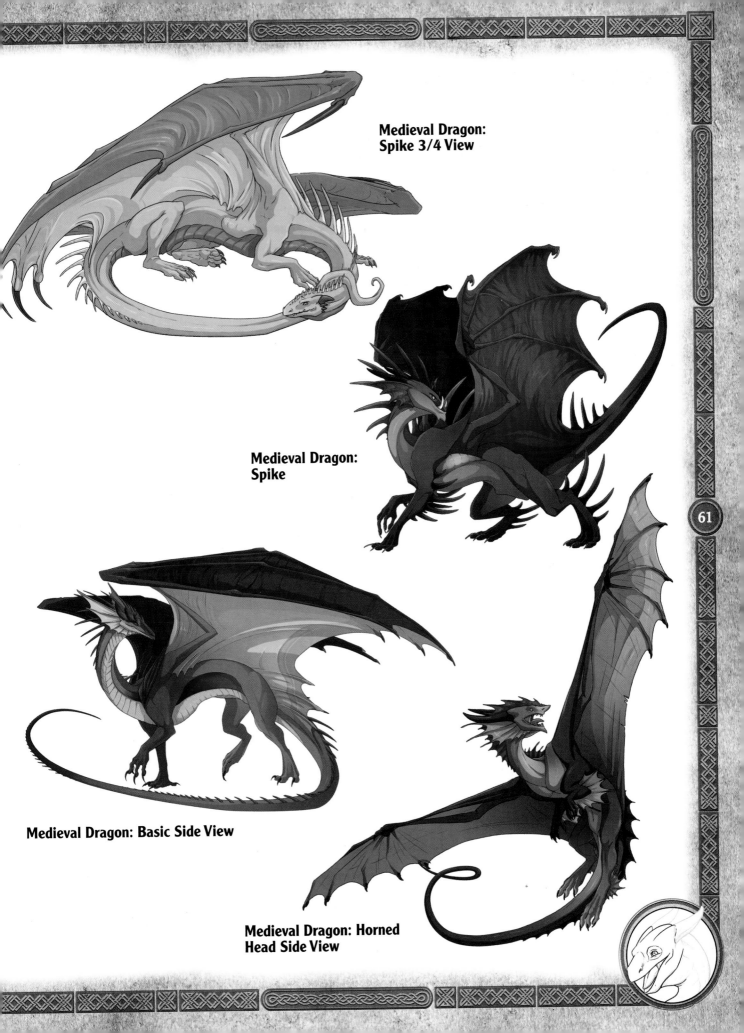

**Medieval Dragon:
Spike 3/4 View**

**Medieval Dragon:
Spike**

Medieval Dragon: Basic Side View

**Medieval Dragon: Horned
Head Side View**

61

Medieval Dragon 🐉 HORNED HEAD: SIDE VIEW

We're going to try drawing a dragon's head from the side, a profile view.

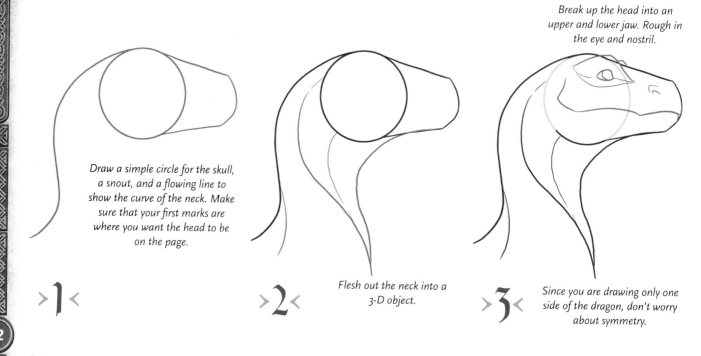

Break up the head into an upper and lower jaw. Rough in the eye and nostril.

Draw a simple circle for the skull, a snout, and a flowing line to show the curve of the neck. Make sure that your first marks are where you want the head to be on the page.

> >1<

Flesh out the neck into a 3-D object.

> >2<

Since you are drawing only one side of the dragon, don't worry about symmetry.

> >3<

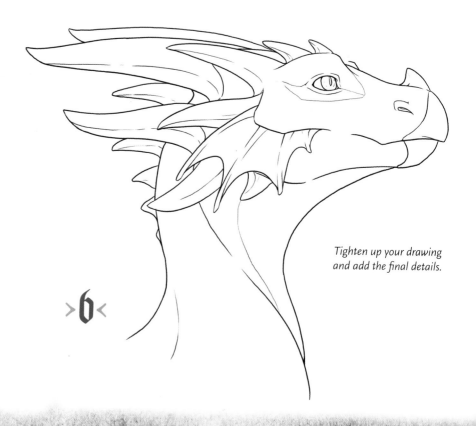

> >6<

Tighten up your drawing and add the final details.

Use spikes, horns, frills, beaks and scales to create an original dragon straight out of your imagination!

Add more rows of horns. For a profile view, create a few horns on the other side of the dragon's head to mirror the side we're seeing.

>4<

>5<

I chose basic black-on-black here. I also added a splash of purple on his facial fins and vibrant green eyes.

>7<

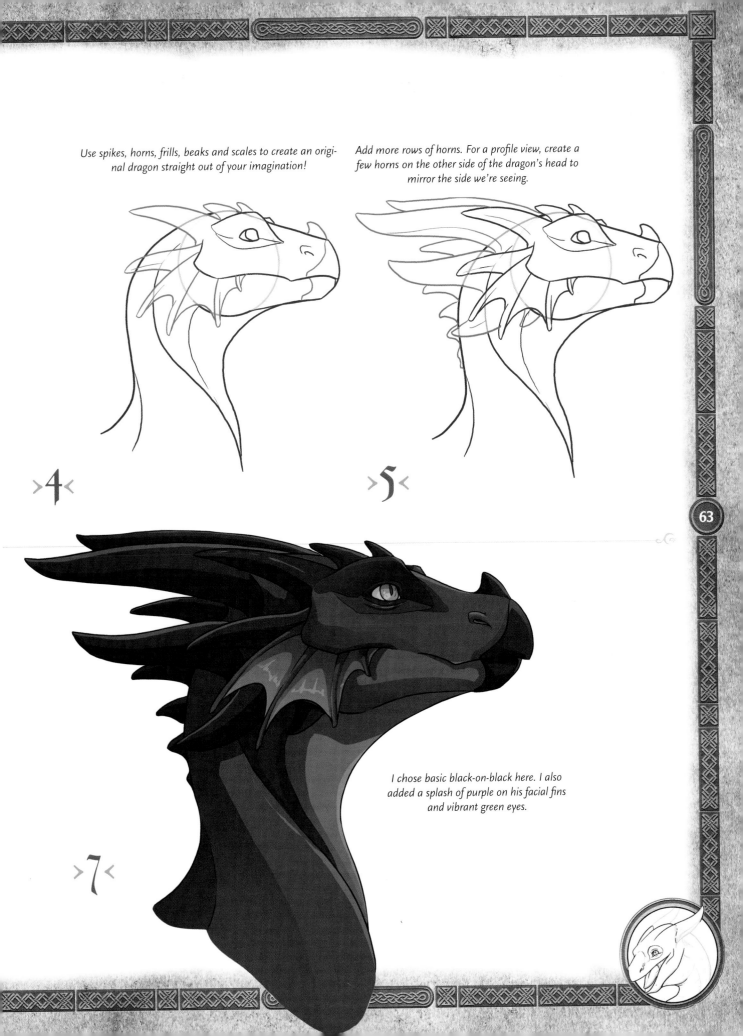

Medieval Dragon ❧ CREST HEAD: FRONT VIEW

A front view of your dragon's head must be symmetrical and take into account the foreshortening that affects the view.

>1<

Draw a circular shape that extends to the back of the skull, a snout, and a line that shows the direction of the neck curves. Split the face down the center with a vertical line for two evenly spaced halves. Put a horizontal line perpendicular to the vertical center line where you want the eyes to go.

>2<

Draw the back of the jaw. Keep both sides roughly the same size. Draw the other side of the neck loosely following the same curve as the back of the neck.

>3<

Add the eyes, spacing them an equal distance from the center line. These are facing forward. If your dragon's eyes naturally look forward, you will be able to see a large section of the eye. If the eyes are on the side of its head like a lizard, then they will face sideways, and from the front you will only see the sides. I decided that my dragon has a different belly texture from the scales that cover his back

Tighten up the drawing and add any remaining details you would like, such as individual scales, wrinkles in the skin, tiny divots in the jaw. This is the time to go wild! When you are finished, erase any stray construction lines.

>6<

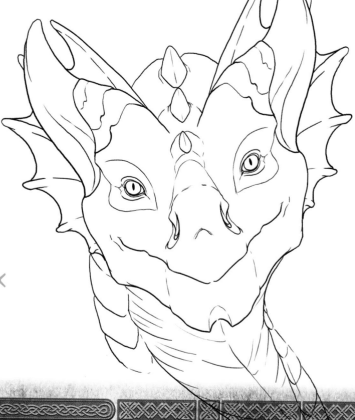

Divide the snout into an upper and lower jaw. Add details into the muzzle such as nostrils and a cleft chin.

>4<

>5<

Add horns, fins, whiskers, manes or whatever facial details you want. I chose a set of gently curved horns and a crest that runs along behind them. Make sure that the details are symmetrical so the face isn't lopsided.

>7<

I decided to give this dragon varying shades of greenish yellow all down his body. The brilliant crest and eyes in orange really pop against the green of the dragon.

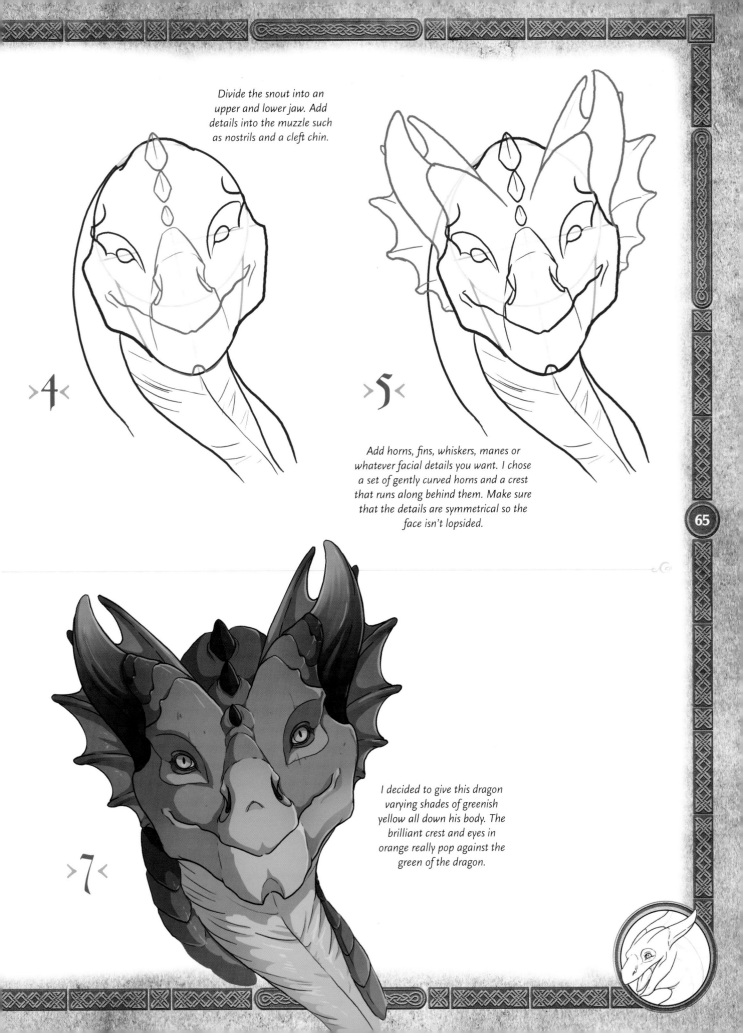

In most illustrations it will be pretty rare to have your dragon facing perfectly forward or be in perfect profile. Often he will be positioned in a way that falls somewhere in between.

Draw where you'd like the snout to be and a loose guide that shows the way the neck bends. Draw a circular shape that extends to the back of the skull from the snout. This is an important step. You do not want your dragon's head to abruptly end once the mouth is finished. Leaving space for the skull means your dragon can have fun things like a brain and a hinge for his mandible.

Thicken the neck and connect the head to it.

Add an eye. I wanted my dragon to have a raised bony brow structure that sits above its eye. Draw a complete brow on the side of the dragon facing us. On the side that's facing away, only a little bit of this brow would show over the top of his head, so I drew in this tiny sliver of brow.

66

Tighten up your lines and add tiny details, such as the individual shapes of the belly scales, the lines of the upper and lower eyelids, and the play of the muscles in your dragon's neck. Erase any stray construction lines.

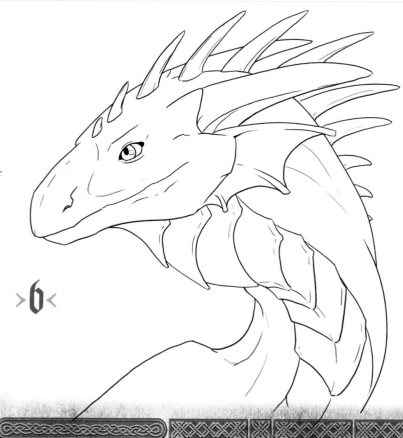

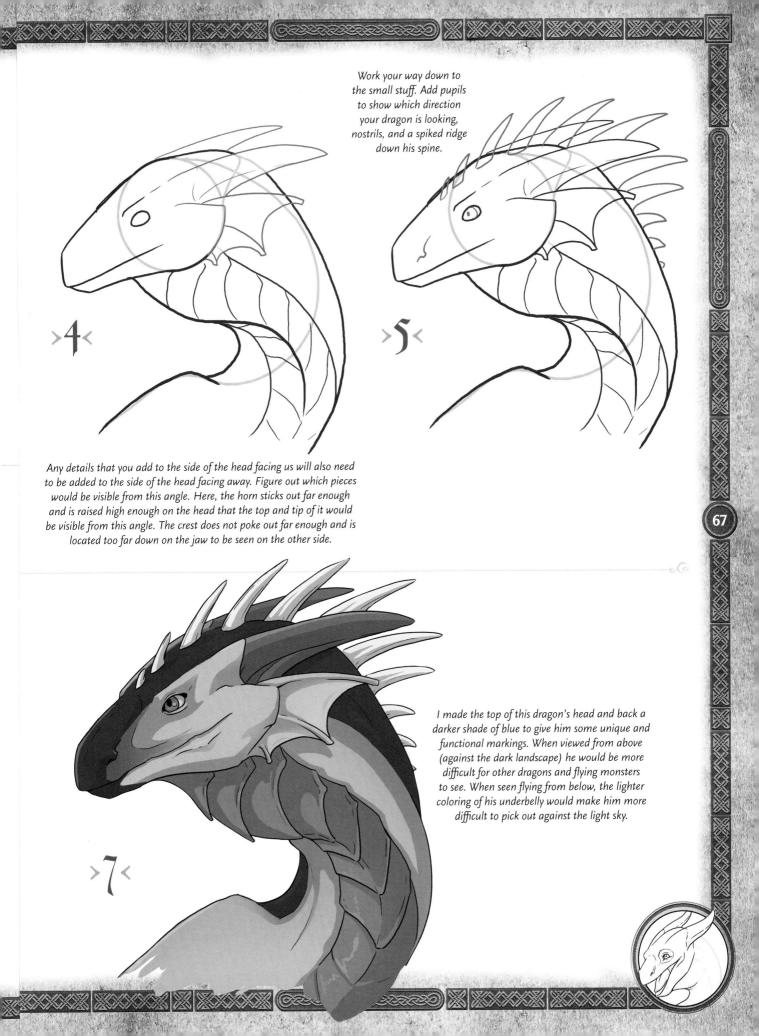

Work your way down to
the small stuff. Add pupils
to show which direction
your dragon is looking,
nostrils, and a spiked ridge
down his spine.

>4<

>5<

Any details that you add to the side of the head facing us will also need
to be added to the side of the head facing away. Figure out which pieces
would be visible from this angle. Here, the horn sticks out far enough
and is raised high enough on the head that the top and tip of it would
be visible from this angle. The crest does not poke out far enough and is
located too far down on the jaw to be seen on the other side.

>7<

I made the top of this dragon's head and back a
darker shade of blue to give him some unique and
functional markings. When viewed from above
(against the dark landscape) he would be more
difficult for other dragons and flying monsters
to see. When seen flying from below, the lighter
coloring of his underbelly would make him more
difficult to pick out against the light sky.

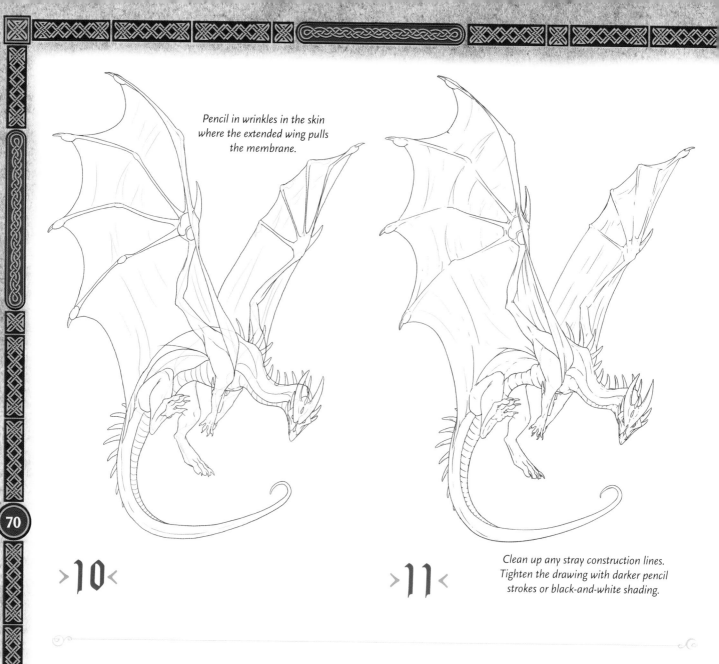

Pencil in wrinkles in the skin where the extended wing pulls the membrane.

> 10 <

> 11 < Clean up any stray construction lines. Tighten the drawing with darker pencil strokes or black-and-white shading.

> 12 < I chose a vibrant emerald for the body, tail and back of the wings so that when viewed from above, he has a similar value to the land below. I chose a light ivory for the underside of his belly and wings so that when viewed from below, he's camouflaged against the sky. Of course, your dragon might be so mighty that he doesn't need camouflage at all!

Place your dragon in an environment that suits him. Since this dragon is in motion, I used a fish-eye-lens approach for the background to draw the viewer's eye to the center of the image. The sun also casts a golden light onto his wings and casts reflections on the waters below.

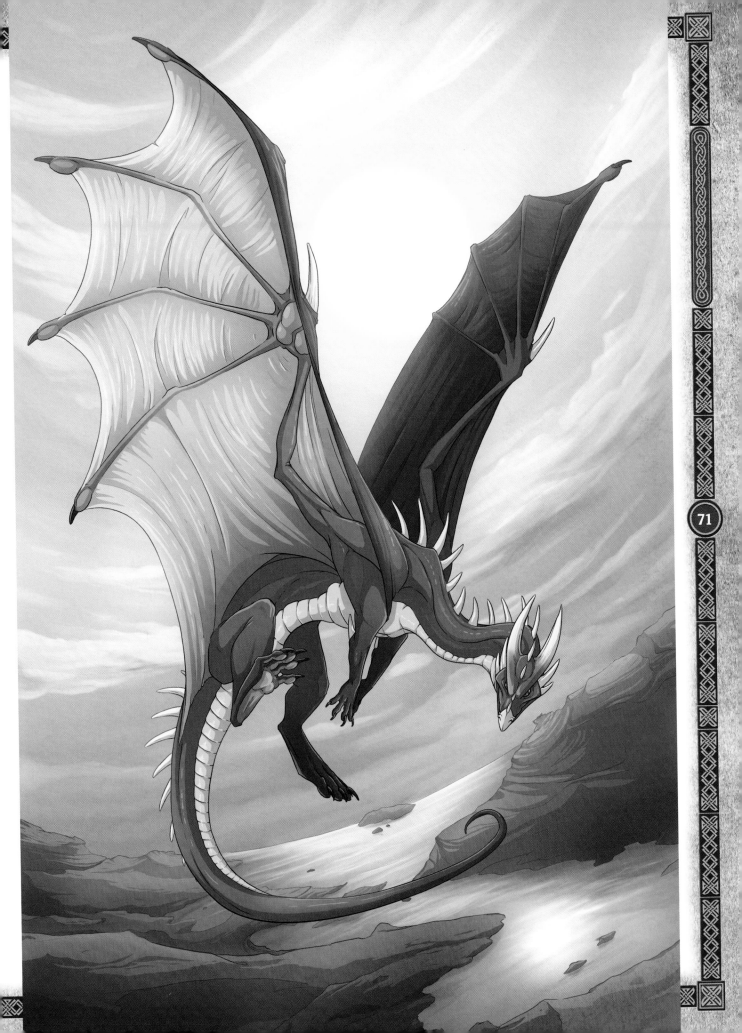

Medieval Dragon **SPIKED DRAGON**

Another variant on the Western-style, medieval dragon is this big, meaty guy. He's huge, he's bulky and he's covered with thick scales and spikes!

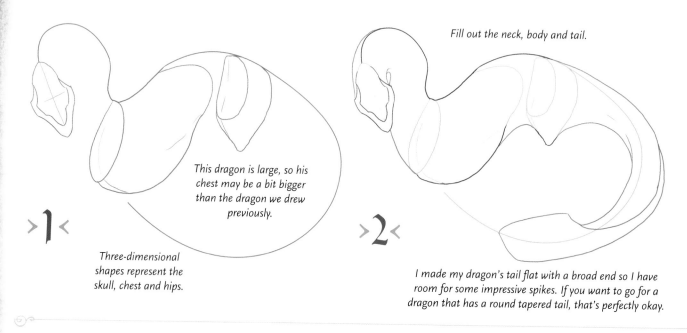

Fill out the neck, body and tail.

>**1**<

This dragon is large, so his chest may be a bit bigger than the dragon we drew previously.

Three-dimensional shapes represent the skull, chest and hips.

>**2**<

I made my dragon's tail flat with a broad end so I have room for some impressive spikes. If you want to go for a dragon that has a round tapered tail, that's perfectly okay.

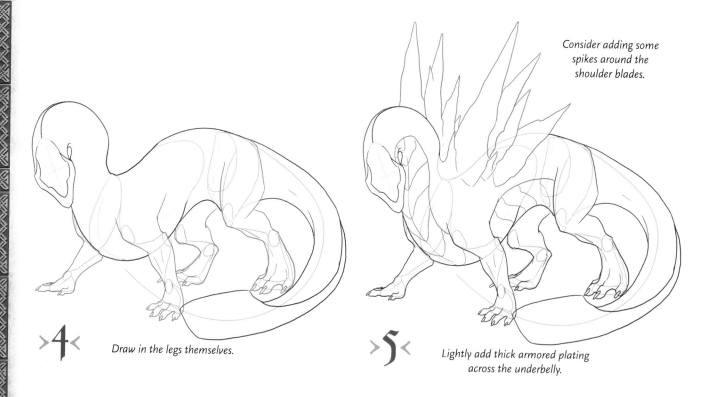

Consider adding some spikes around the shoulder blades.

>**4**<

Draw in the legs themselves.

>**5**<

Lightly add thick armored plating across the underbelly.

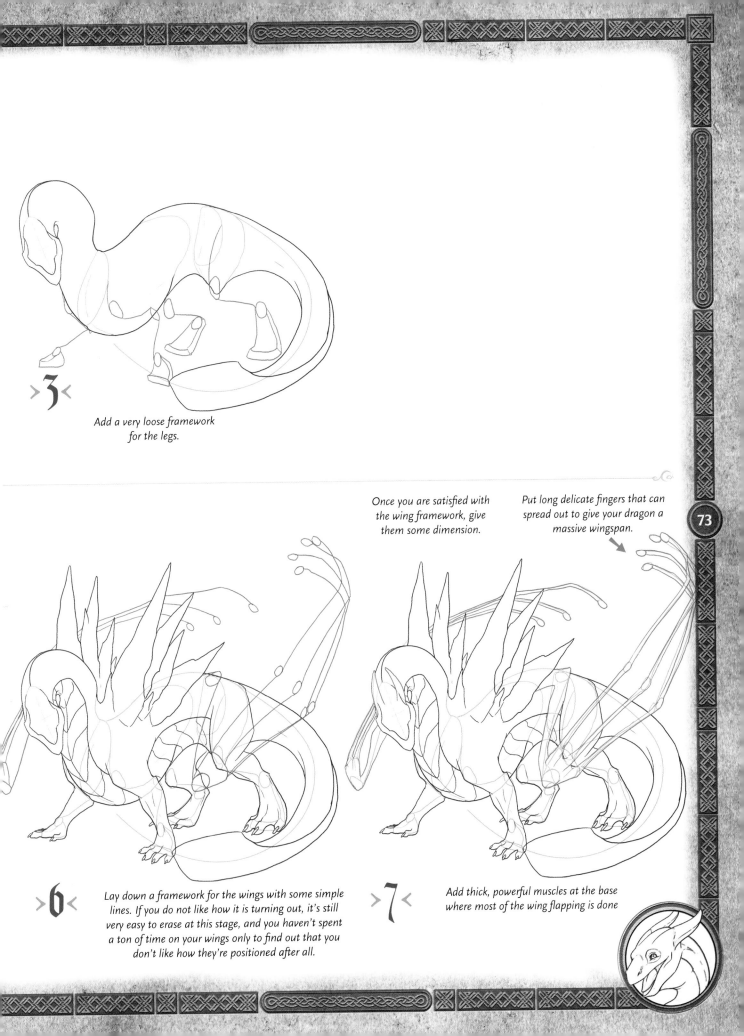

>3<

Add a very loose framework
for the legs.

Once you are satisfied with
the wing framework, give
them some dimension.

Put long delicate fingers that can
spread out to give your dragon a
massive wingspan.

73

>6< Lay down a framework for the wings with some simple
lines. If you do not like how it is turning out, it's still
very easy to erase at this stage, and you haven't spent
a ton of time on your wings only to find out that you
don't like how they're positioned after all.

>7< Add thick, powerful muscles at the base
where most of the wing flapping is done

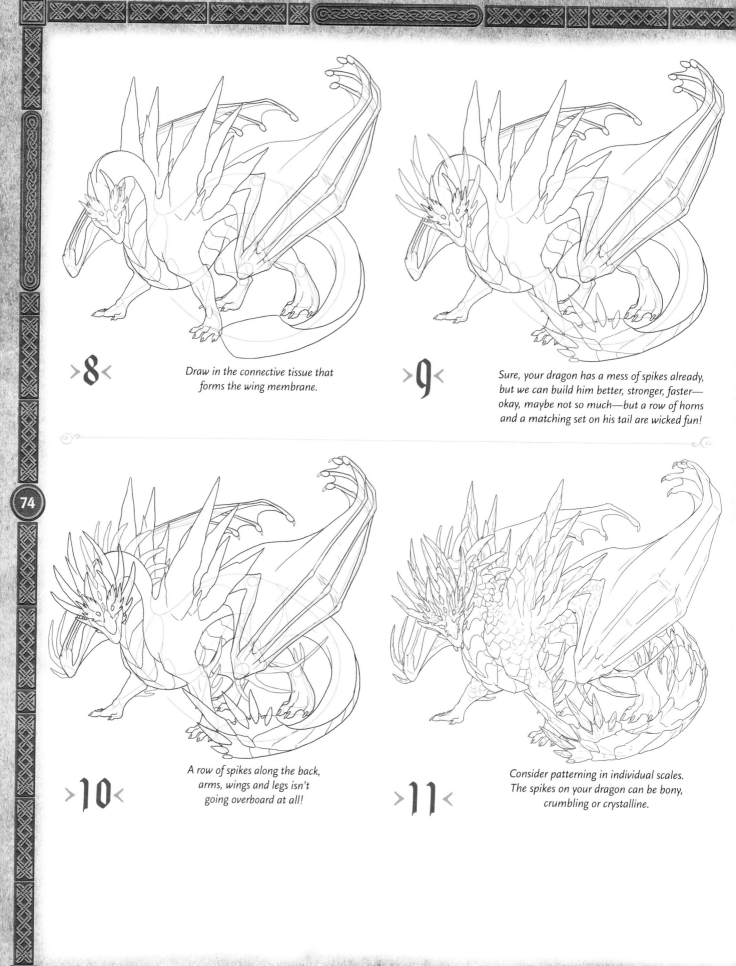

>**8**<

Draw in the connective tissue that forms the wing membrane.

>**9**<

Sure, your dragon has a mess of spikes already, but we can build him better, stronger, faster—okay, maybe not so much—but a row of horns and a matching set on his tail are wicked fun!

>**10**<

A row of spikes along the back, arms, wings and legs isn't going overboard at all!

>**11**<

Consider patterning in individual scales. The spikes on your dragon can be bony, crumbling or crystalline.

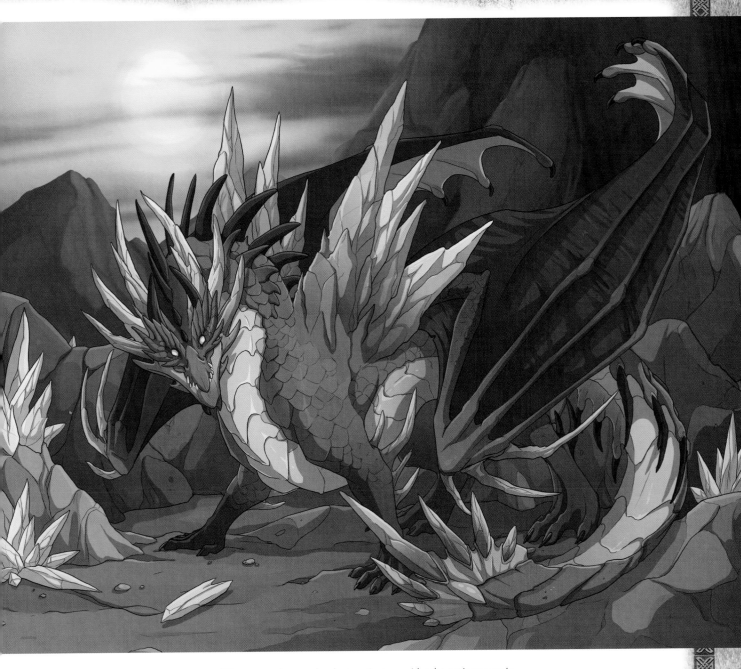

When you color your lumbering giant, consider the environment in which he lives. With this dragon's massive spikes on his shoulders, I hazarded that he did not get much airtime, and so he is colored to camouflage with his rocky surroundings. If you fancy your spiked behemoth an arctic or jungle dragon, color him accordingly.

LUNG DRAGON

Unlike its often monstrous medieval Western cousin, Eastern lung dragons are often portrayed as benevolent creatures, and a favorable sign to those lucky enough to encounter them. The lung dragon is a long, serpentine creature, with the scales of a carp, the claws of an eagle, and the horns of a deer. They are able to soar through the heavens without the use of wings, a magical feat indeed

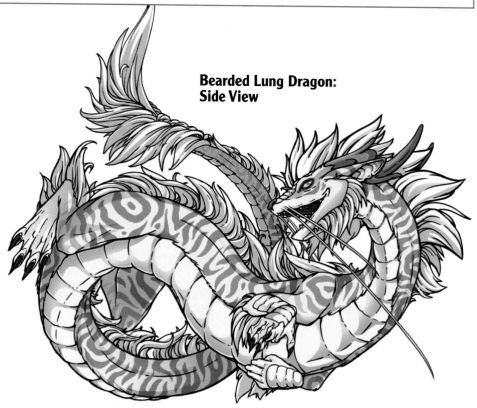

Bearded Lung Dragon: Side View

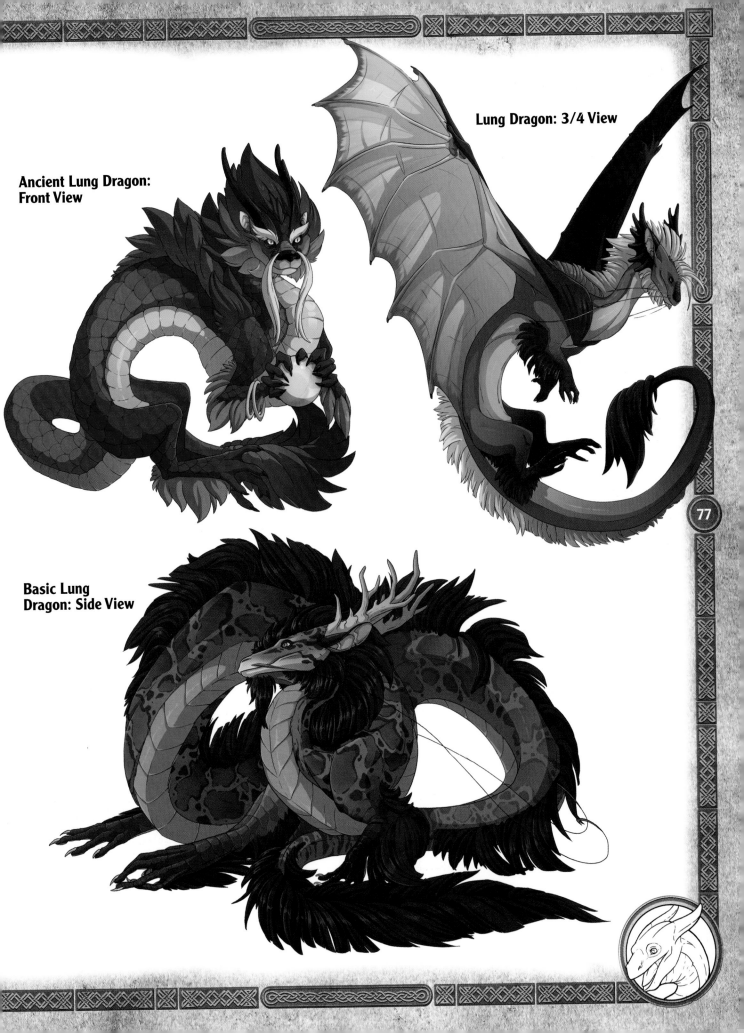

Lung Dragon: 3/4 View

Ancient Lung Dragon:
Front View

Basic Lung
Dragon: Side View

77

The profile view of a dragon is the easiest. You do not need to worry about perspective or symmetry; it is very straightforward. If you are a beginner, this is always the view I recommend you try first.

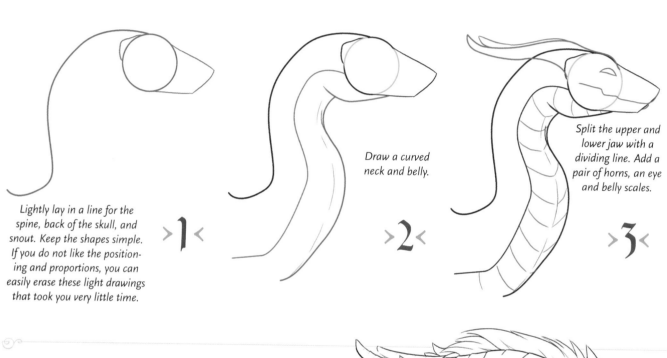

Lightly lay in a line for the spine, back of the skull, and snout. Keep the shapes simple. If you do not like the positioning and proportions, you can easily erase these light drawings that took you very little time.

> 1 <

Draw a curved neck and belly.

> 2 <

Split the upper and lower jaw with a dividing line. Add a pair of horns, an eye and belly scales.

> 3 <

78

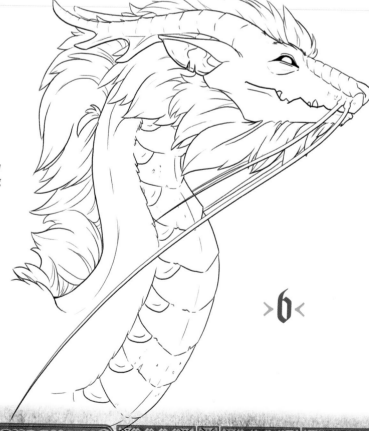

Erase any construction lines that you no longer need, and begin tightening your line work and pressing harder with your pencil. If you wish, you may ink your drawing

> 6 <

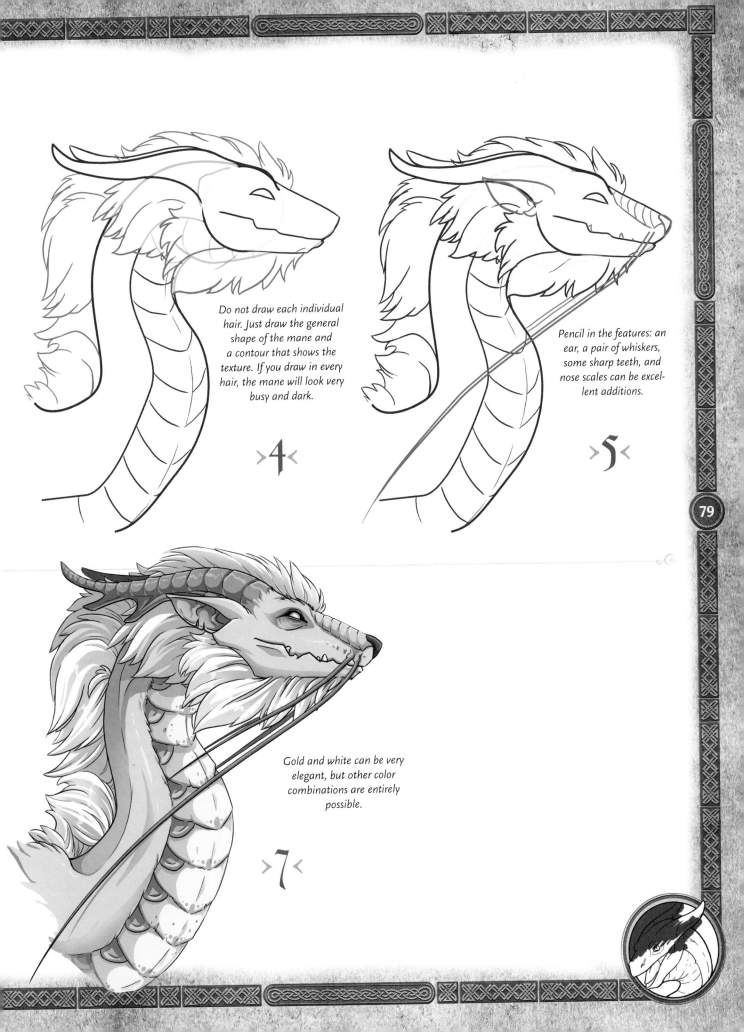

Do not draw each individual hair. Just draw the general shape of the mane and a contour that shows the texture. If you draw in every hair, the mane will look very busy and dark.

>4<

Pencil in the features: an ear, a pair of whiskers, some sharp teeth, and nose scales can be excellent additions.

>5<

Gold and white can be very elegant, but other color combinations are entirely possible.

>7<

Tackling the front view for any dragon can be challenging, as you have to be especially careful to make the face symmetrical and account for the foreshortening of the snout of your beastie.

Sketch out quick skull, spine and snout placement shapes.

Draw a center line down the skull vertically, and loosely pencil in a horizontal line perpendicular to it for the eyeline. (Depending on the style of dragon you're drawing, this may not always be in the center.)

Draw a thick, curved neck and refine the facial structure, adding in a jaw that's wide toward the back and tapers down the snout.

80

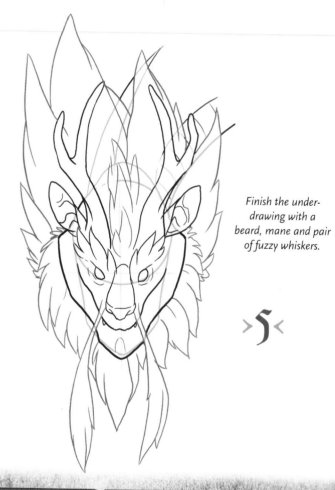

Finish the under-drawing with a beard, mane and pair of fuzzy whiskers.

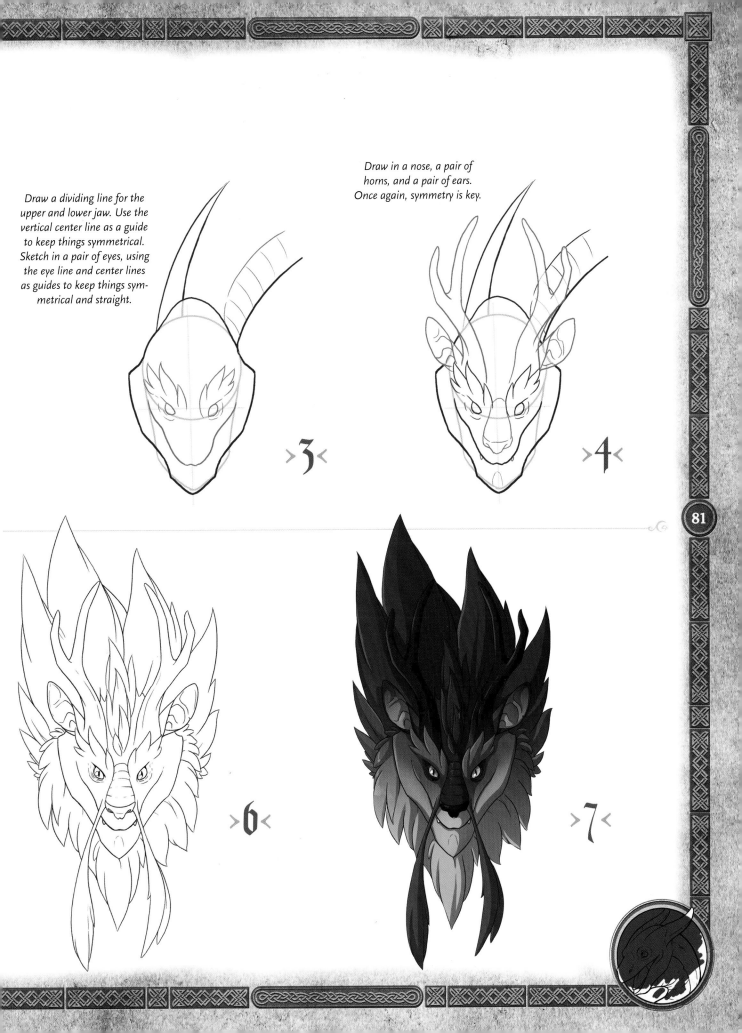

Draw a dividing line for the upper and lower jaw. Use the vertical center line as a guide to keep things symmetrical. Sketch in a pair of eyes, using the eye line and center lines as guides to keep things symmetrical and straight.

Draw in a nose, a pair of horns, and a pair of ears. Once again, symmetry is key.

>3<

>4<

>6<

>7<

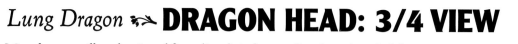

Most dragons will not be viewed from directly in front or directly to the side. The head is often rotated up or down, left or right to some degree. The 3/4 view can be challenging at first because you have to keep the head looking as if all its facial features are still in alignment, while having an image that is itself not perfectly symmetrical.

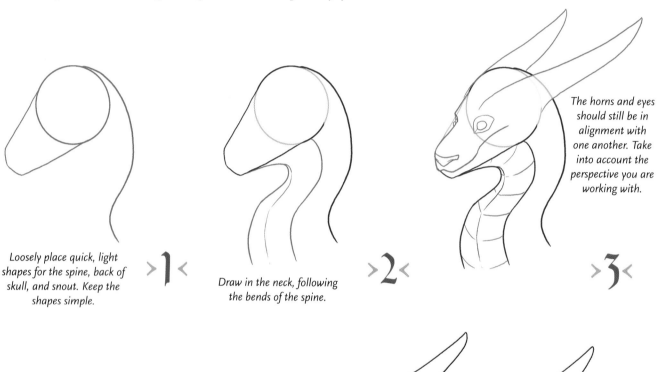

Loosely place quick, light shapes for the spine, back of skull, and snout. Keep the shapes simple.

>1<

Draw in the neck, following the bends of the spine.

>2<

The horns and eyes should still be in alignment with one another. Take into account the perspective you are working with.

>3<

82

Erase any stray construction lines you no longer desire and refine your drawing. You can add in more details, like the texture of the fur and the pupils to the eyes.

>6<

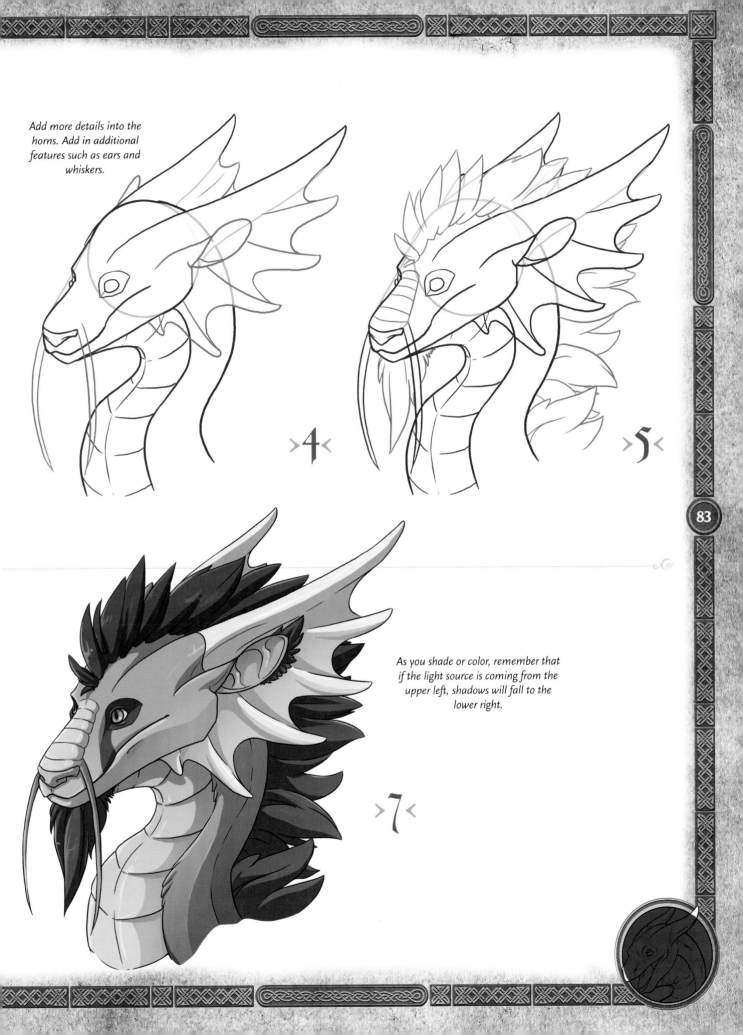

Add more details into the
horns. Add in additional
features such as ears and
whiskers.

>4<

>5<

83

As you shade or color, remember that
if the light source is coming from the
upper left, shadows will fall to the
lower right.

>7<

Lung Dragon 🌿 **FULL DRAGON**

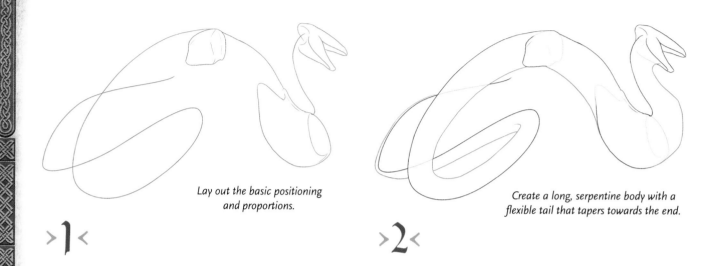

Lay out the basic positioning
and proportions.

>**1**<

Create a long, serpentine body with a
flexible tail that tapers towards the end.

>**2**<

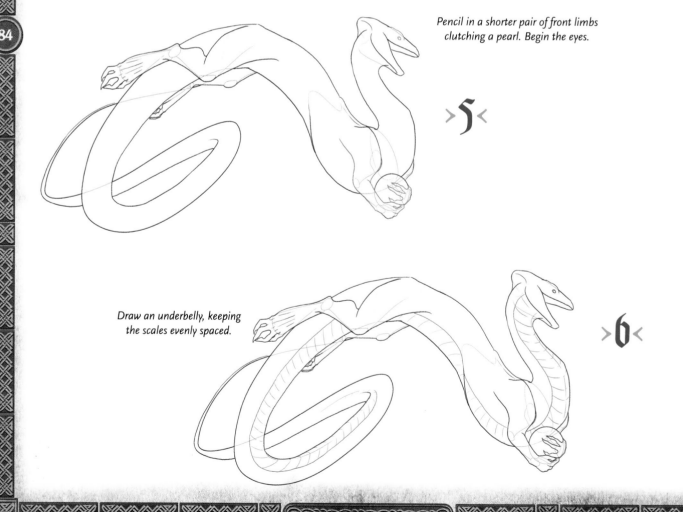

Pencil in a shorter pair of front limbs
clutching a pearl. Begin the eyes.

>**5**<

Draw an underbelly, keeping
the scales evenly spaced.

>**6**<

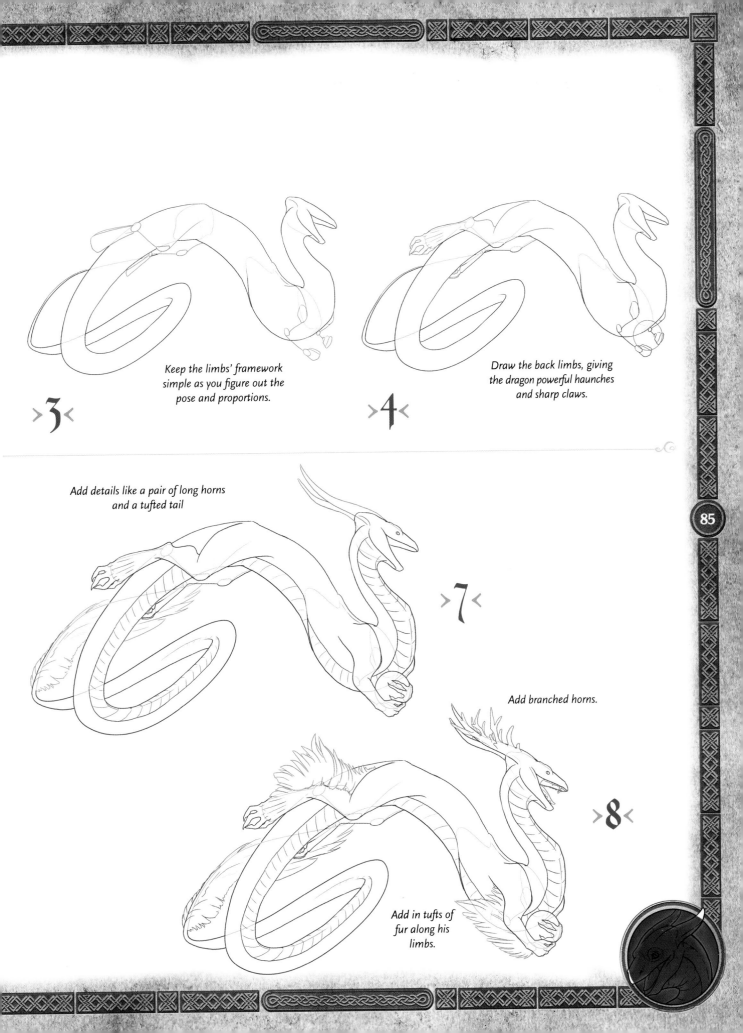

Keep the limbs' framework simple as you figure out the pose and proportions.

>3<

Draw the back limbs, giving the dragon powerful haunches and sharp claws.

>4<

Add details like a pair of long horns and a tufted tail

>7<

Add branched horns.

>8<

Add in tufts of fur along his limbs.

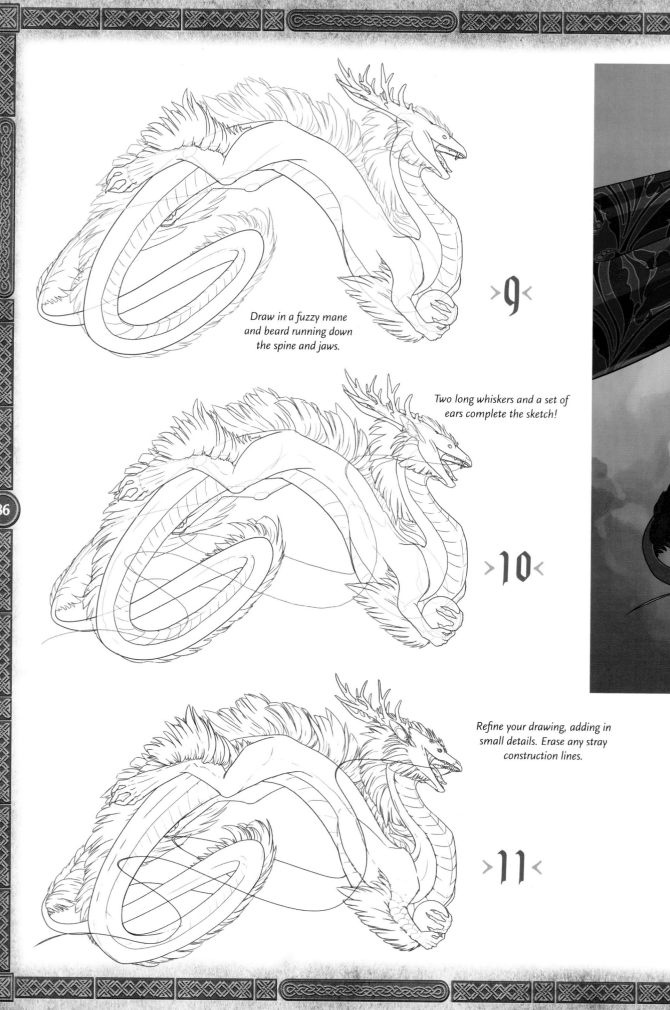

Draw in a fuzzy mane
and beard running down
the spine and jaws.

>9<

Two long whiskers and a set of
ears complete the sketch!

>10<

Refine your drawing, adding in
small details. Erase any stray
construction lines.

>11<

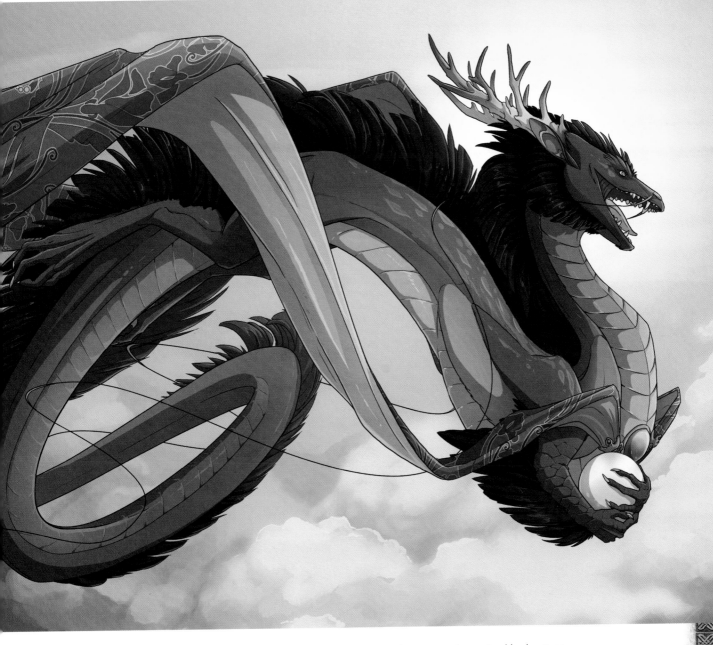

Eastern dragons may be great golden beasts or fire engine red. If you like, you can place your dragon in an environment where he can soar through the clouds or watch over a river.

>12<

DRAGON HATCHLINGS

There are certain characteristics to keep in mind when drawing dragon hatchlings to make them look like babies, instead of just small adult dragons. Typical characteristics include:

- Large heads in comparison to body size. A hatchling's head is roughly the same size as the chest and hips.
- Shorter spine.
- Large eyes within the head.
- Sometimes toothless.
- Stubby limbs, tail and wings.
- Soft and round body type.
- Unsharpened horns and a figure padded in baby fat.

Hatchling to Adult

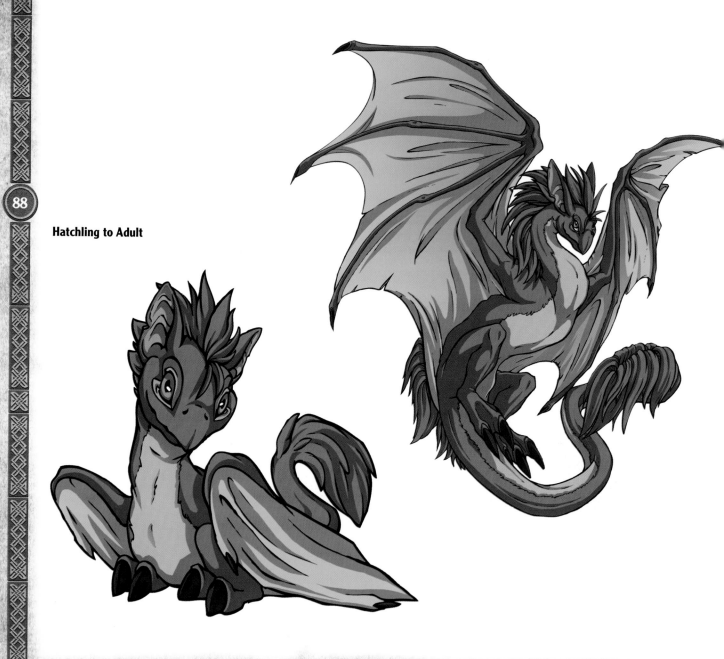

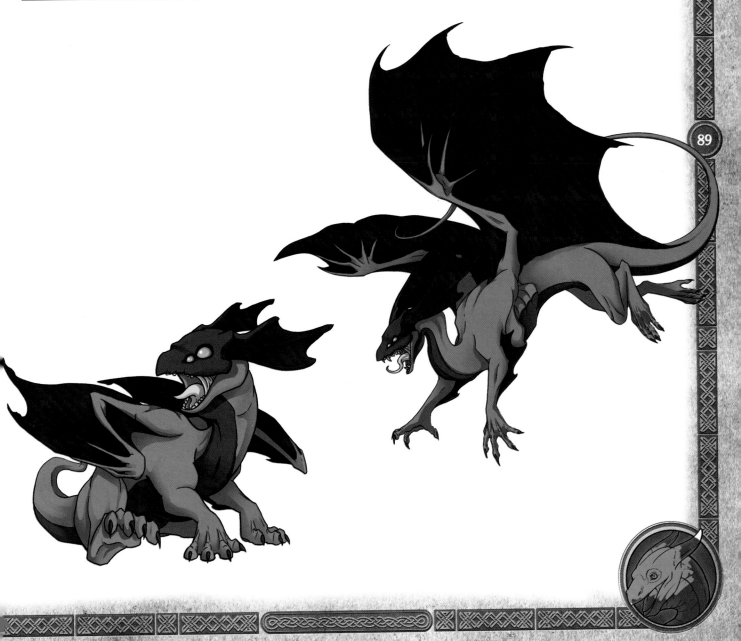

Dragon Hatchlings ✤ **WESTERN**

Western dragon hatchlings often walk on four limbs and have a pair of batlike wings on their backs. They may not yet sport a full set of horns on their heads, but these grow in with time. They may not be able to breathe fire at this early age, but rest assured that when they grow up, they will go from being little terrors to being…large and terrible!

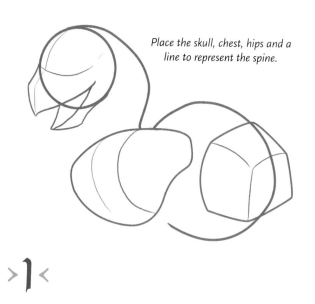

Place the skull, chest, hips and a line to represent the spine.

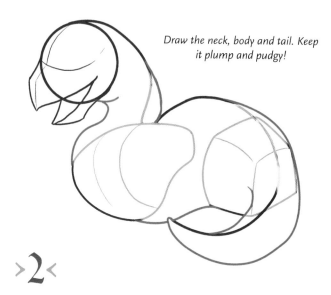

Draw the neck, body and tail. Keep it plump and pudgy!

>1<

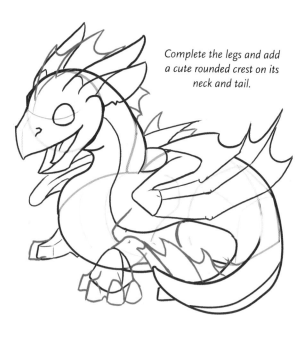

Complete the legs and add a cute rounded crest on its neck and tail.

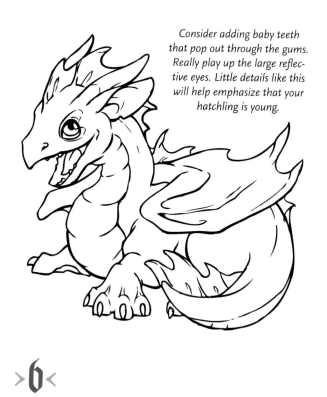

Consider adding baby teeth that pop out through the gums. Really play up the large reflective eyes. Little details like this will help emphasize that your hatchling is young.

>5<

>6<

Add a pair of large eyes and sketch in the framework for a pair of stubby wings. This baby is not yet ready for flight.

Add a membrane stretched between the wing's spines, and put down a quick framework for the legs. Remember that the legs may be stubby, but the baby might still have big paws, like a puppy.

>3<

>4<

Your hatchling may share the exact same coloring as the dragon it will turn into, or it may be a duller version of the color to help camouflage it for protection while it is young and vulnerable.

>7<

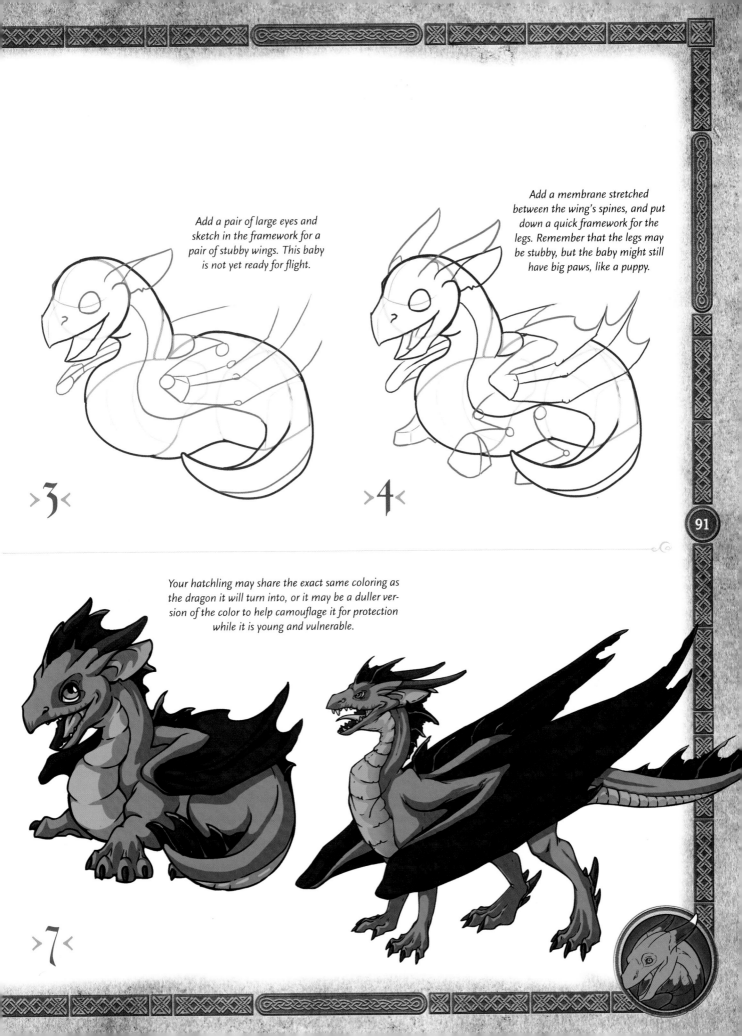

Dragon Hatchlings 🐉 EASTERN

Eastern dragons have an elongated body, so your baby will have a body that's much longer than a Western dragon, but not quite as long in proportion to its head as an adult.

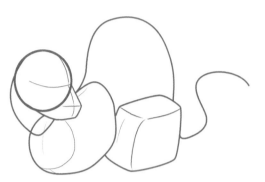

Place the skull, chest, hips, and a line to represent the spine.

>1<

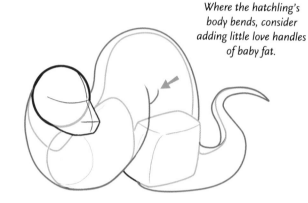

Where the hatchling's body bends, consider adding little love handles of baby fat.

>2<

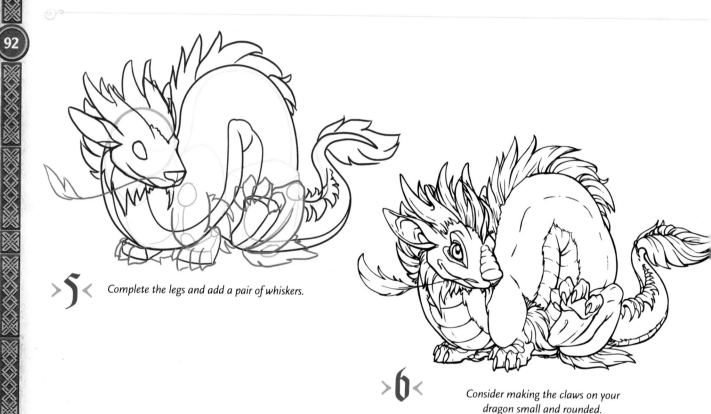

>5< *Complete the legs and add a pair of whiskers.*

>6<

Consider making the claws on your dragon small and rounded.

92

Add large eyes, big floppy ears, and branched horns that are small and rounded at the tips.

>3<

Add a mane down the back of your dragon's neck, body and tail.

>4<

Loosely sketch in where the limbs will be. They're likely to be short: He'll grow into them later!

>7<

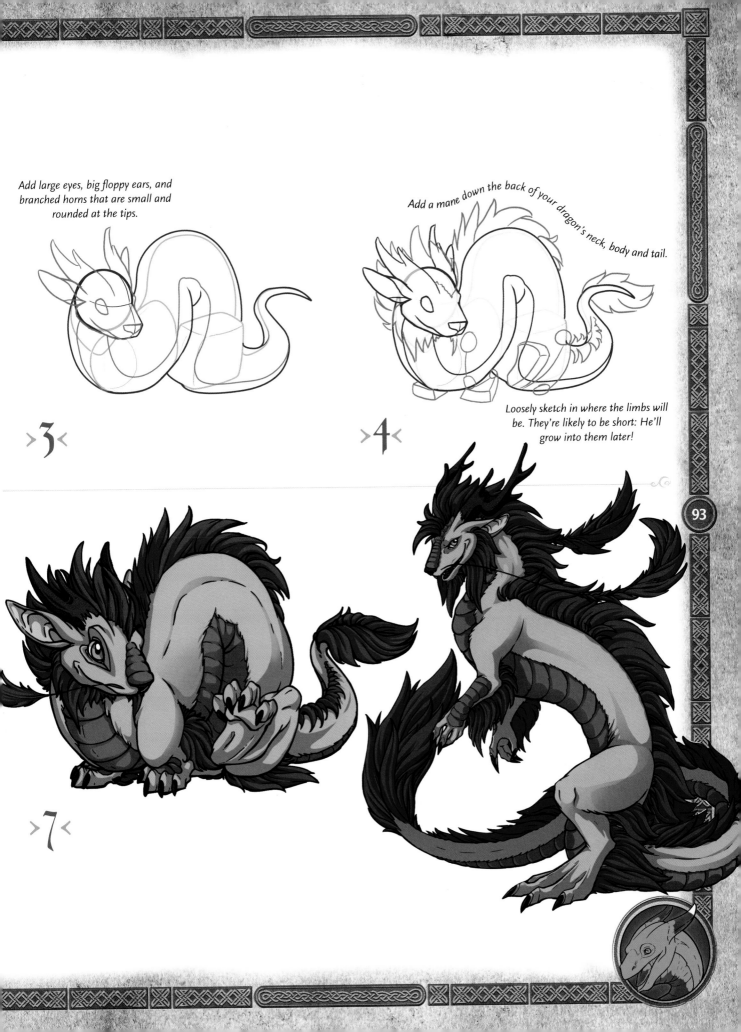

Dragon Hatchlings 🌿 **FAIRY**

The smallest of the dragons starts out tinier than you might be able to imagine! Your baby fae dragon will mimic an adult in miniature. Its wings may not yet be fully functional or brightly colored.

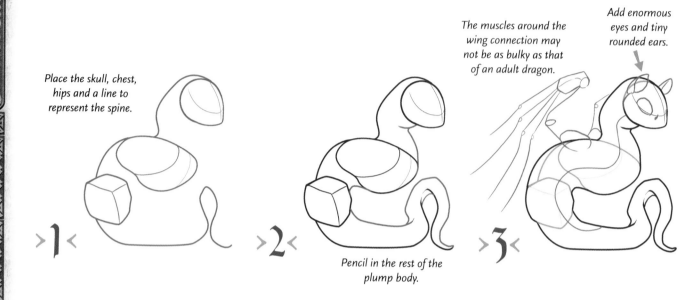

Place the skull, chest, hips and a line to represent the spine.

The muscles around the wing connection may not be as bulky as that of an adult dragon.

Add enormous eyes and tiny rounded ears.

>1<

>2<

Pencil in the rest of the plump body.

>3<

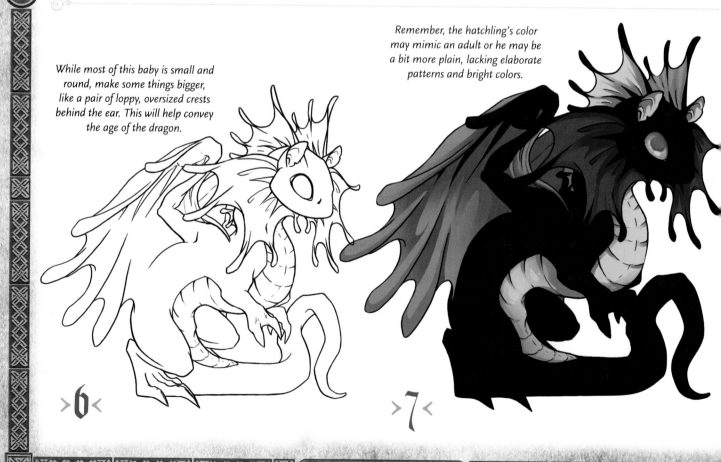

While most of this baby is small and round, make some things bigger, like a pair of loppy, oversized crests behind the ear. This will help convey the age of the dragon.

Remember, the hatchling's color may mimic an adult or he may be a bit more plain, lacking elaborate patterns and bright colors.

>6<

>7<

94

Connect the spines of the wings with gentle U shapes, forming the membrane stretched between them. Don't extend the U shapes up too far into the wing to avoid them looking too sharp and dangerous.

Add in any crests or decoration that you desire

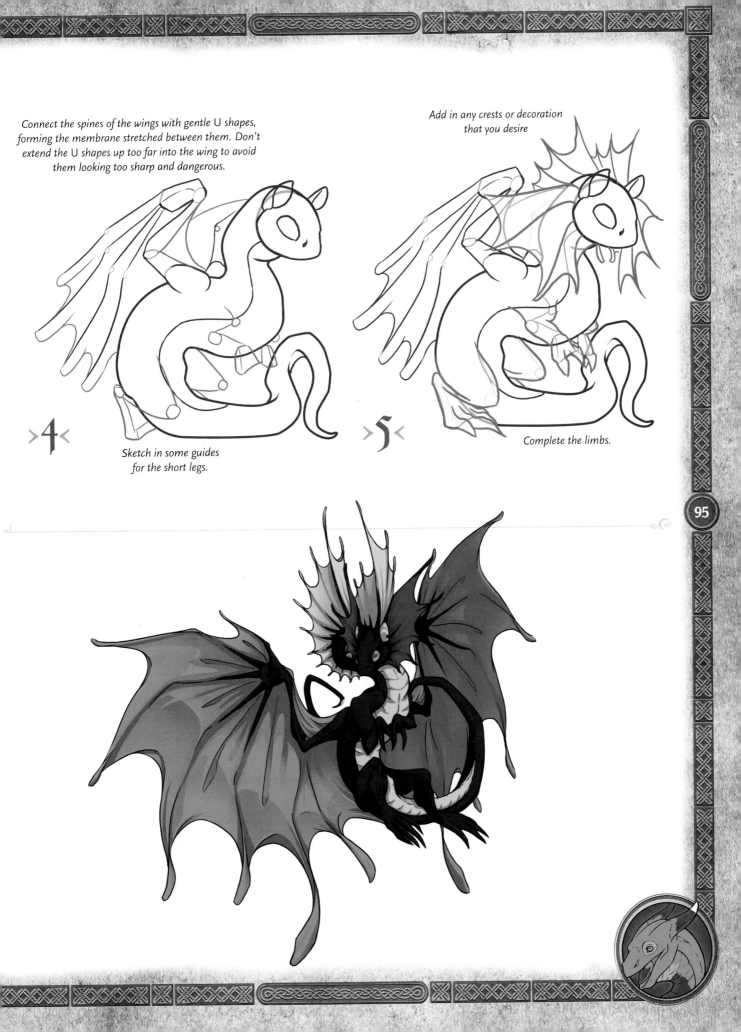

> 4 <

Sketch in some guides for the short legs.

> 5 <

Complete the limbs.

95

Dragon Hatchlings ⤳ FROST

Your frost hatchling is born fully scaled and much heavier than the typical dragon. These sorts of adaptations will help it stay warm in icy climates. Though he may be small now, he will someday grow into a mighty beast who guards or terrorizes the arctic poles!

Add a pair of large eyes and define the upper and lower jaw. Give him an oversized crest and wings that he'll need to grow into.

Place the skull, chest, hips and a line to represent the spine.

96

>1<

Pencil in the rest of the plump body.

>2<

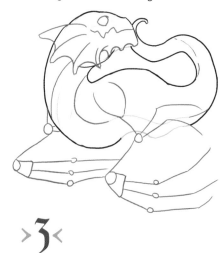

>3<

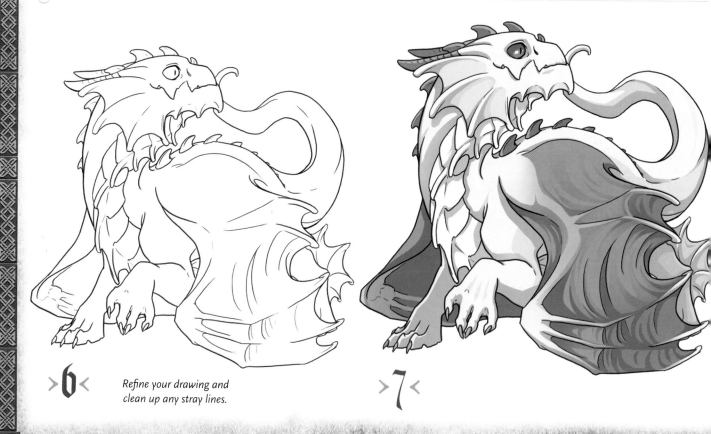

>6<

Refine your drawing and clean up any stray lines.

>7<

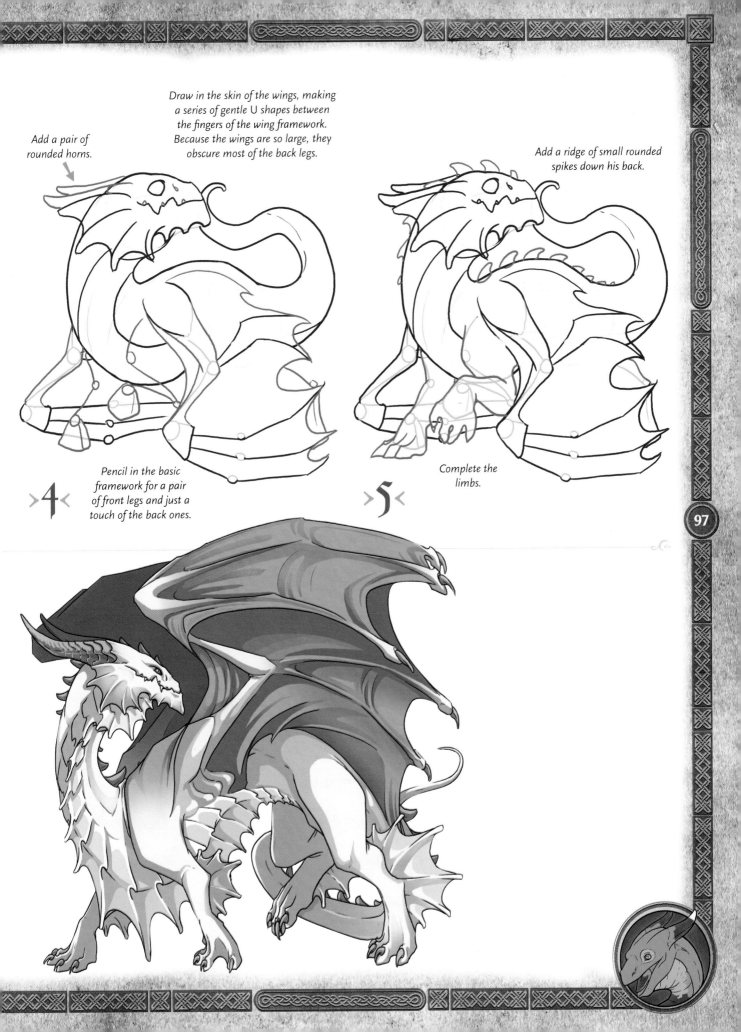

Add a pair of
rounded horns.

Draw in the skin of the wings, making
a series of gentle U shapes between
the fingers of the wing framework.
Because the wings are so large, they
obscure most of the back legs.

Add a ridge of small rounded
spikes down his back.

›4‹ Pencil in the basic
framework for a pair
of front legs and just a
touch of the back ones.

›5‹ Complete the
limbs.

FAIRY DRAGON

Dragons can come in all shapes and sizes, from the great beasts large enough to move mountains, to the delicate fae dragons who can land on a twig without disturbing it. Fae dragons have a lot less weight to support than larger dragons, so both their anatomy and the scale of the objects around them will convey that. A dragon with thin, delicate legs and wings and large eyes in proportion to its head appears much smaller and lighter than dragons that are more stout and heavily muscled.

Fairy Dragons are small enough to be mistaken for butterflies by the untrained eye.

I eat butterflies for breakfast, tiny creature!

Stop frightening the subject matter!

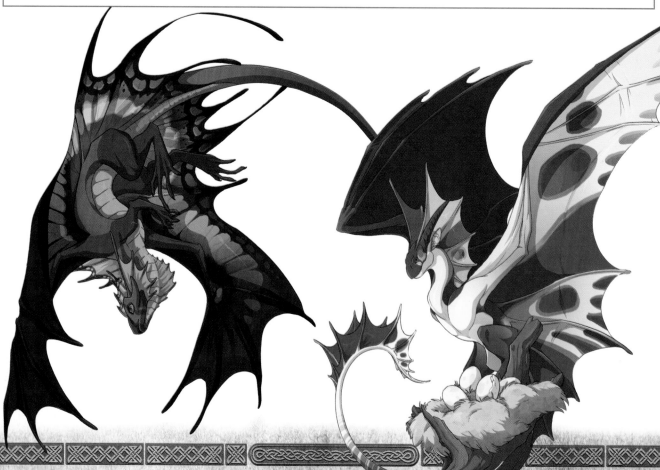

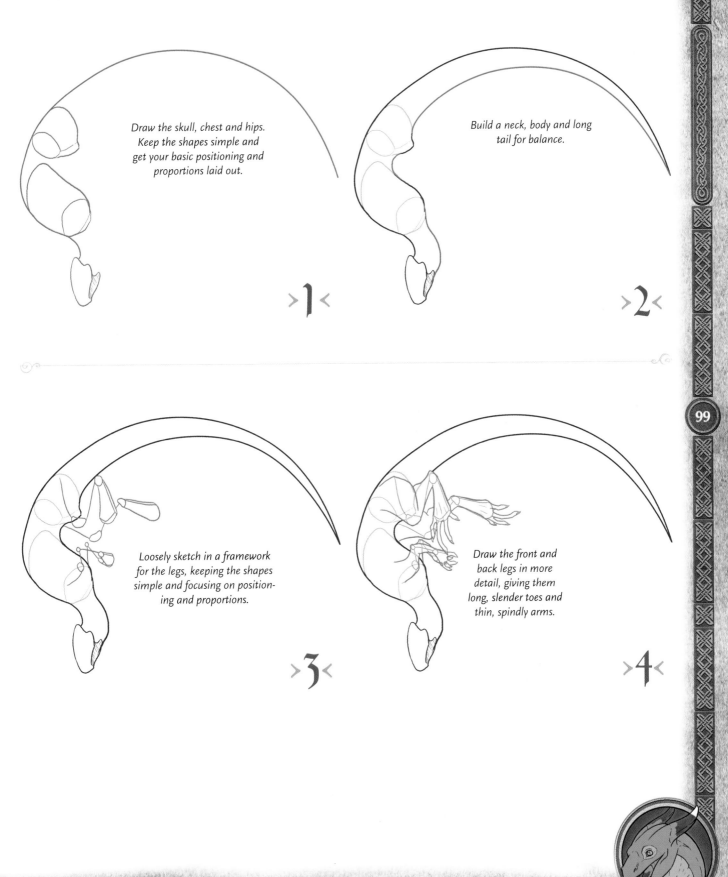

Draw the skull, chest and hips. Keep the shapes simple and get your basic positioning and proportions laid out.

>1<

Build a neck, body and long tail for balance.

>2<

Loosely sketch in a framework for the legs, keeping the shapes simple and focusing on positioning and proportions.

>3<

Draw the front and back legs in more detail, giving them long, slender toes and thin, spindly arms.

>4<

99

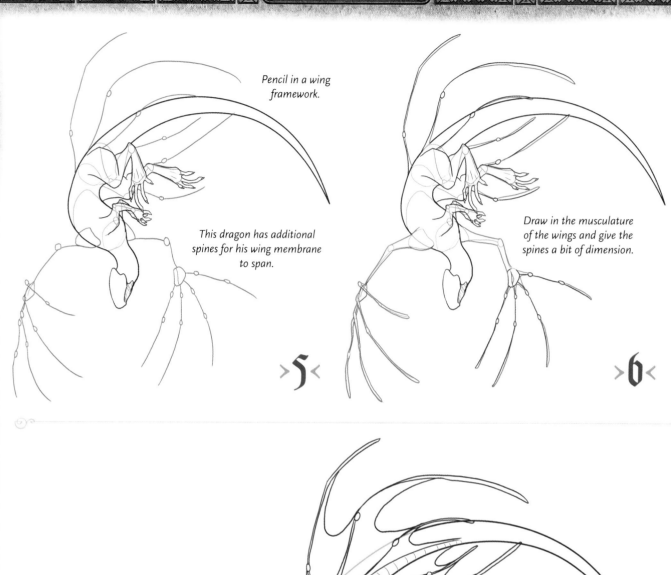

Pencil in a wing framework.

This dragon has additional spines for his wing membrane to span.

Draw in the musculature of the wings and give the spines a bit of dimension.

>5<

>6<

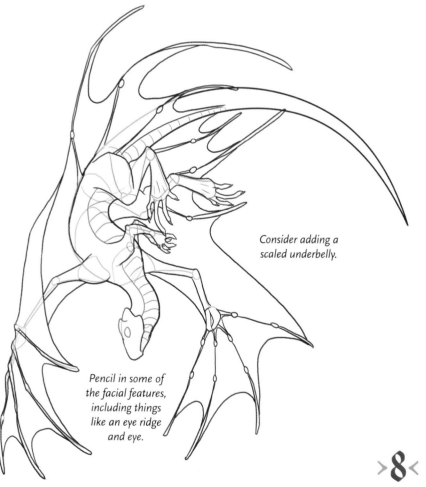

Consider adding a scaled underbelly.

Pencil in some of the facial features, including things like an eye ridge and eye.

>8<

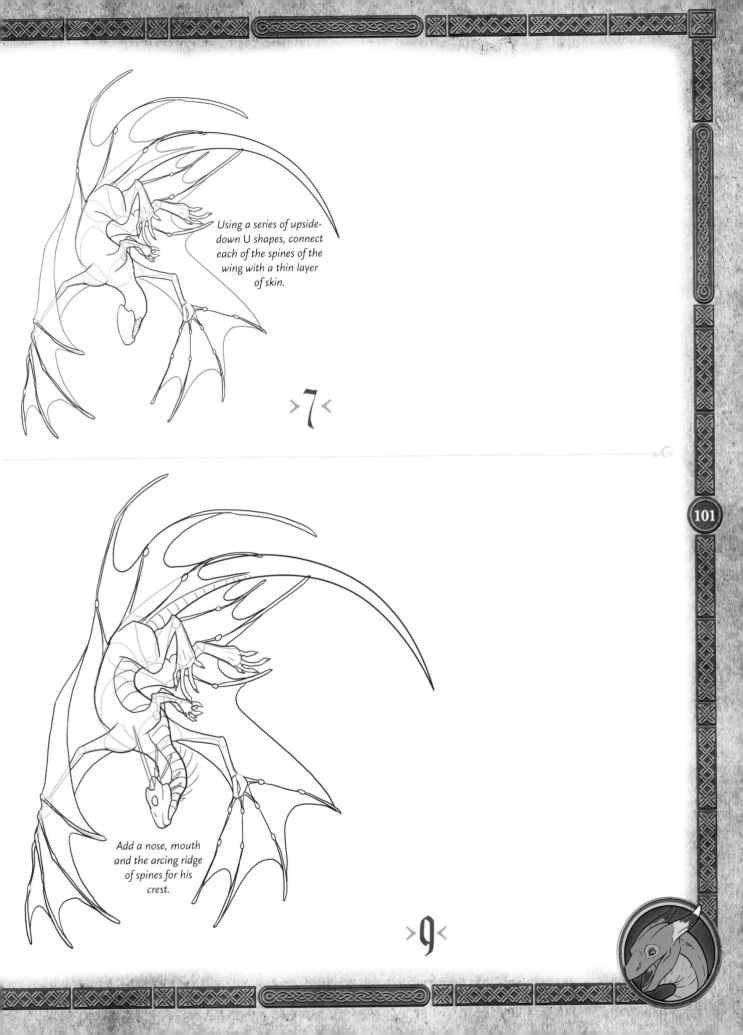

Using a series of upside-down U shapes, connect each of the spines of the wing with a thin layer of skin.

>7<

Add a nose, mouth and the arcing ridge of spines for his crest.

>9<

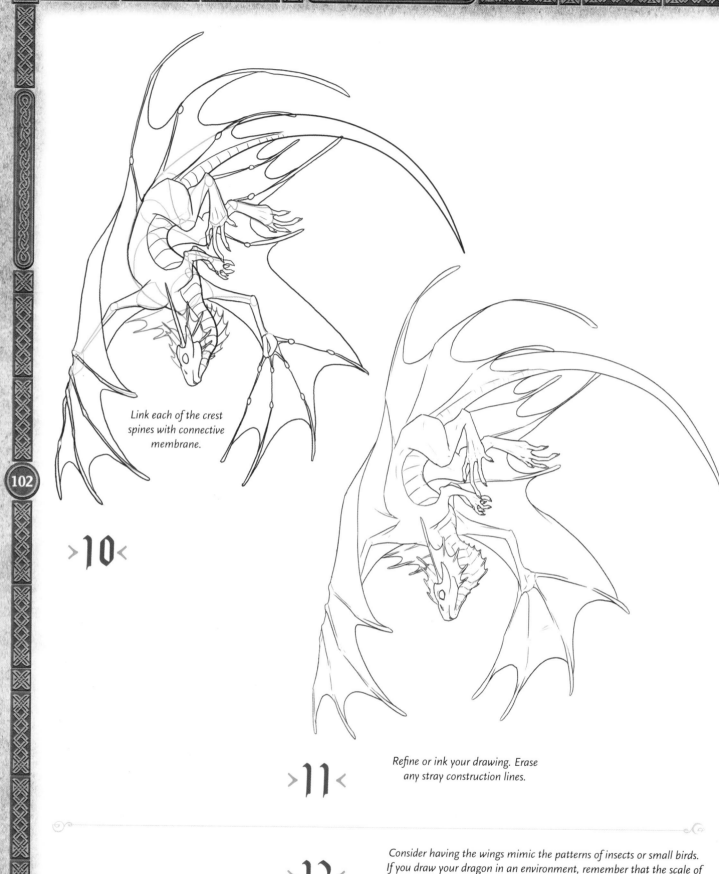

Link each of the crest spines with connective membrane.

>10<

>11<

Refine or ink your drawing. Erase any stray construction lines.

>12<

Consider having the wings mimic the patterns of insects or small birds. If you draw your dragon in an environment, remember that the scale of the objects surrounding him will help to emphasize just how small he really is. You will get a greater sense of scale showing him next to flowers and moss in the immediate foreground than you will by having him fly against a cloudless sky, where there is no basis of comparison.

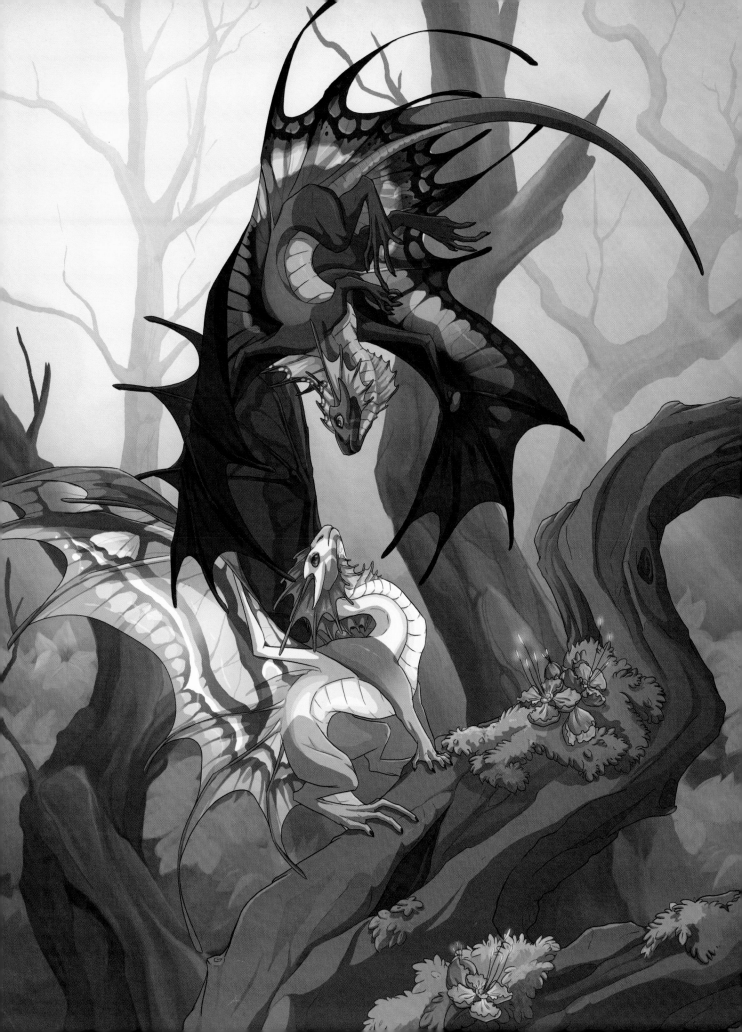

SEA DRAGON

Sea dragons can take many forms. They can be great leviathans too large to fly or crawl onto land. They can be sinuous serpents that coil and crush the unfortunate fleets that skim the surface of their domains, or even poisonous, tropical beasts, seemingly more fish than reptile. Consider where your dragon lives. "Underwater" is a broad term. A dragon that dwells miles beneath the surface of the ocean would have to be able to withstand great pressure and would likely have adaptations to enable it to live without light. A dragon that dwells in a tropical reef will be different than one who dwells in the icy waters of the north.

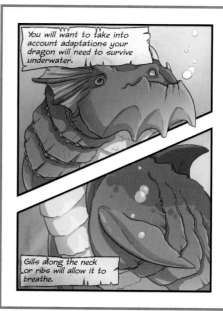

You will want to take into account adaptations your dragon will need to survive underwater.

Gills along the neck or ribs will allow it to breathe.

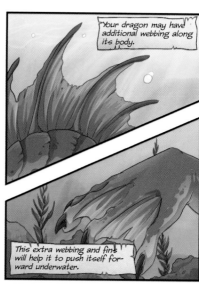

Your dragon may have additional webbing along its body.

This extra webbing and fins will help it to push itself forward underwater.

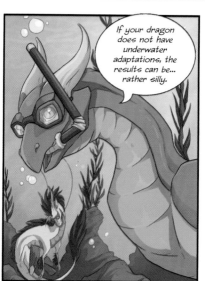

If your dragon does not have underwater adaptations, the results can be... rather silly.

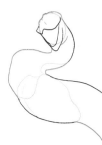
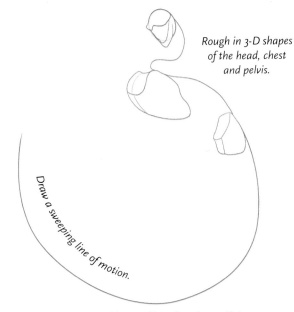

Rough in 3-D shapes of the head, chest and pelvis.

Draw a sweeping line of motion.

If you don't like your line of motion or if the chest placement looks off, no worries! You have spent only a minute on this step and it is still early enough to change.

 1 <

Flesh out the simple lines and shapes. Use the first line of motion and the head, chest and pelvis placements as a guide to create the neck, body and tail.

> 2 <

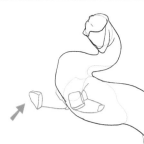

Using very quick, rough lines, decide where the limbs go and how they will bend. This dragon has four webbed limbs. Connect the front limbs to the upper portion of the chest at the shoulder, and the back limbs to the pelvis.

Of course, he doesn't have to have four limbs. Perhaps it has no limbs and propels itself through the water using its fins. Or front flippers and a larger tail? It's really up to you and your imagination.

> 3 <

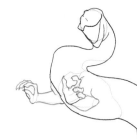

Render the thickness and the musculature of the limbs. For detailed information on dragon limbs, refer to Part 1.

> 4 <

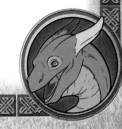

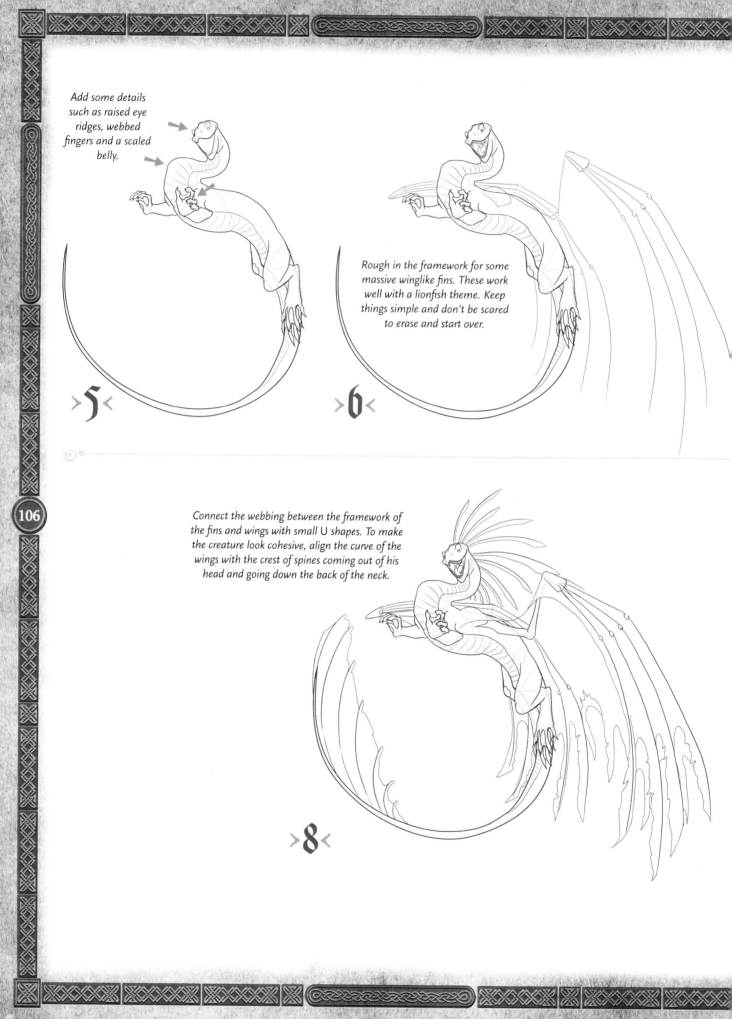

Add some details such as raised eye ridges, webbed fingers and a scaled belly.

>5<

Rough in the framework for some massive winglike fins. These work well with a lionfish theme. Keep things simple and don't be scared to erase and start over.

>6<

106

Connect the webbing between the framework of the fins and wings with small U shapes. To make the creature look cohesive, align the curve of the wings with the crest of spines coming out of his head and going down the back of the neck.

>8<

Draw some quick lines to use as guides for more fins or spines. Make sure you're satisfied with your arcs before moving to the next step.

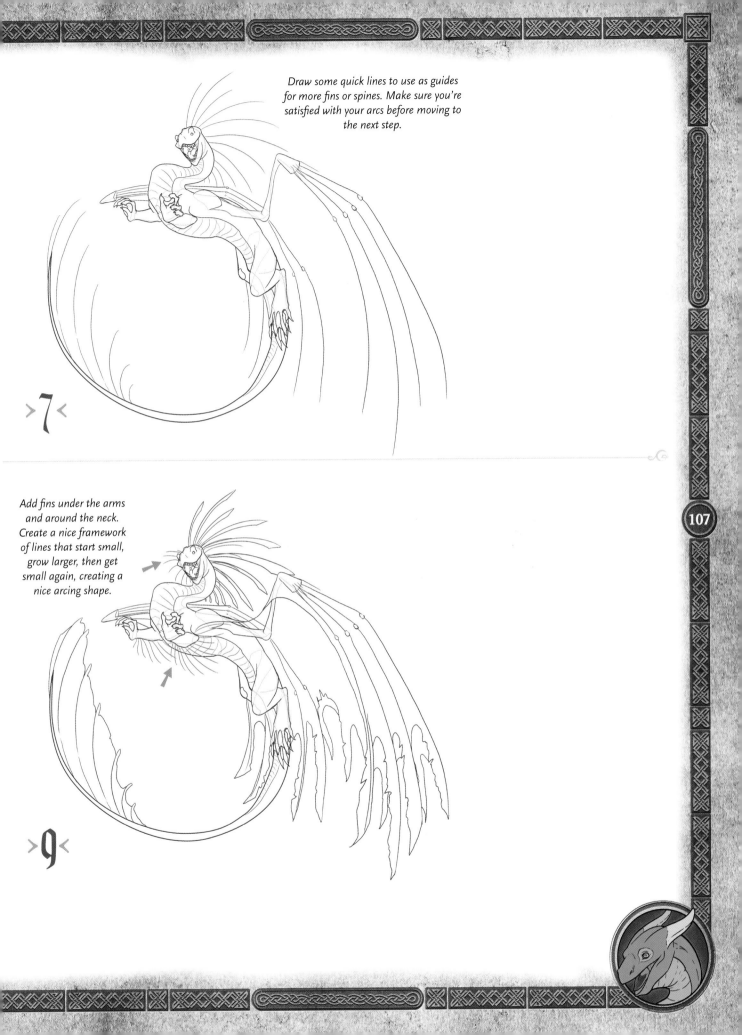

> 7 <

Add fins under the arms and around the neck. Create a nice framework of lines that start small, grow larger, then get small again, creating a nice arcing shape.

> 9 <

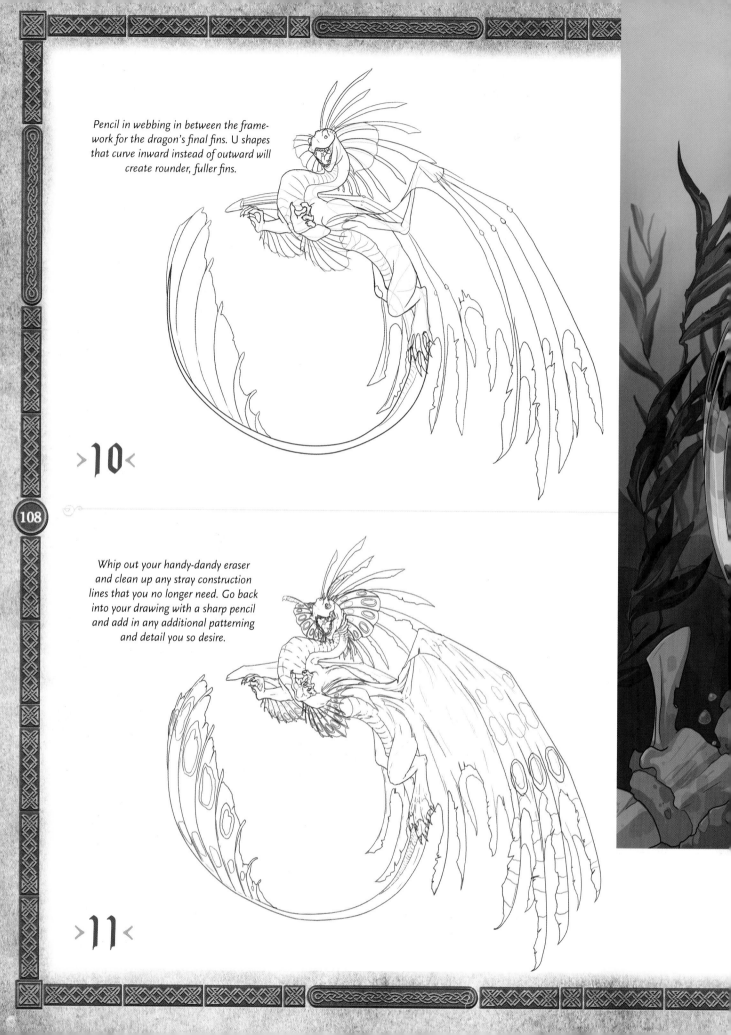

Pencil in webbing in between the framework for the dragon's final fins. U shapes that curve inward instead of outward will create rounder, fuller fins.

> 10 <

108

Whip out your handy-dandy eraser and clean up any stray construction lines that you no longer need. Go back into your drawing with a sharp pencil and add in any additional patterning and detail you so desire.

> 11 <

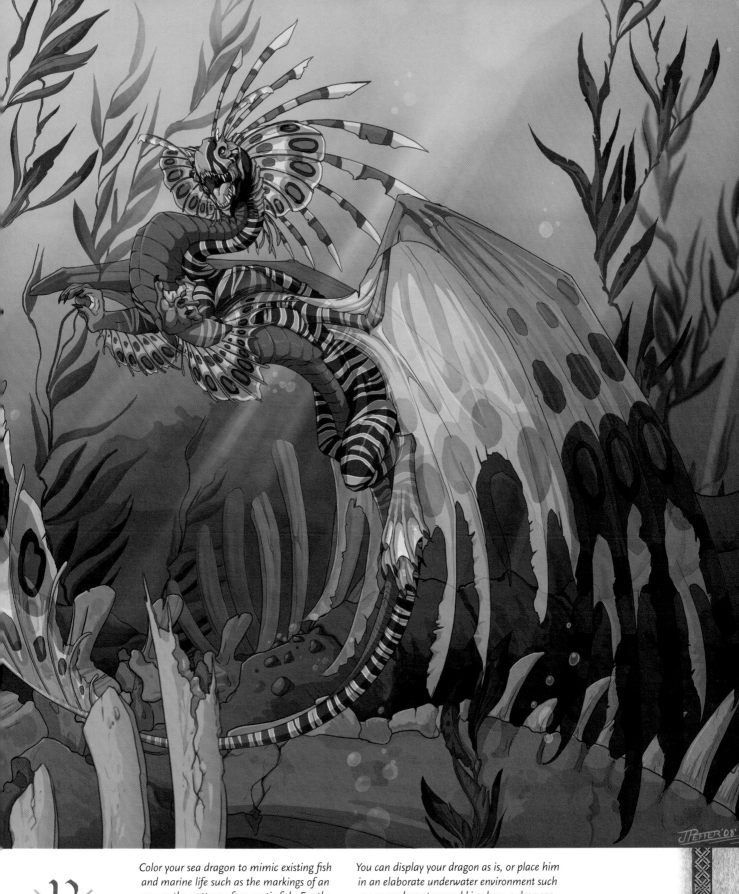

> 12 <

Color your sea dragon to mimic existing fish and marine life such as the markings of an orca or the pattern of an exotic fish. For the lionfish motif in this dragon, I patterned the spine, body and fins with shades of blue.

You can display your dragon as is, or place him in an elaborate underwater environment such as an underwater coral kingdom, a deep sea space full of glowing creatures, or an aquatic graveyard. The possibilities are endless!

DRAGON LICH

All good things must come to an end...but evil things think that's rather dull, so they like to stick around long after their natural end has come and gone. Meet the dragon lich: He's big, he's bad, and he may or may not be falling apart. It doesn't matter whether your undead dragon is a rotting zombie, an animated skeleton, or a dragon spirit; he's going to be a heck of a lot of fiendishly good fun to draw either way.

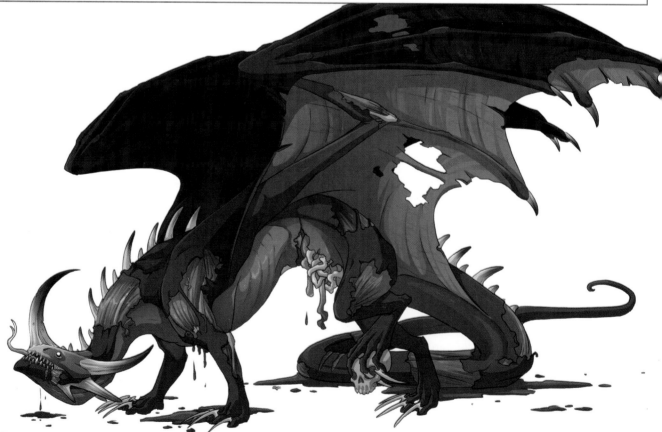

Establish the curve of the spine and tail, and the placement of the head, chest and hips.

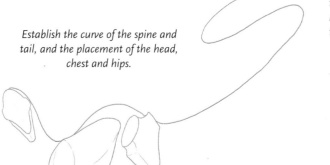

>**1**<

At this point I'd normally say "flesh out the body," but with an undead dragon, it's really your choice whether or not you want to. Perhaps he is bones connected together with nothing more than a few pieces of rotting meat.

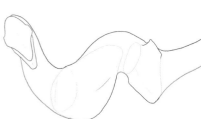

I filled out and connected the disjointed pieces of this dragon, but it's entirely optional.

>**2**<

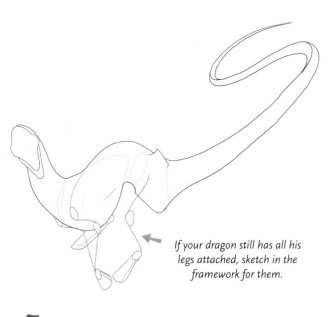

If your dragon still has all his legs attached, sketch in the framework for them.

>**3**<

Refine the legs and give him a set of wicked claws. They say that after you die, your hair and nails keep growing a while longer, so why not!?

>**4**<

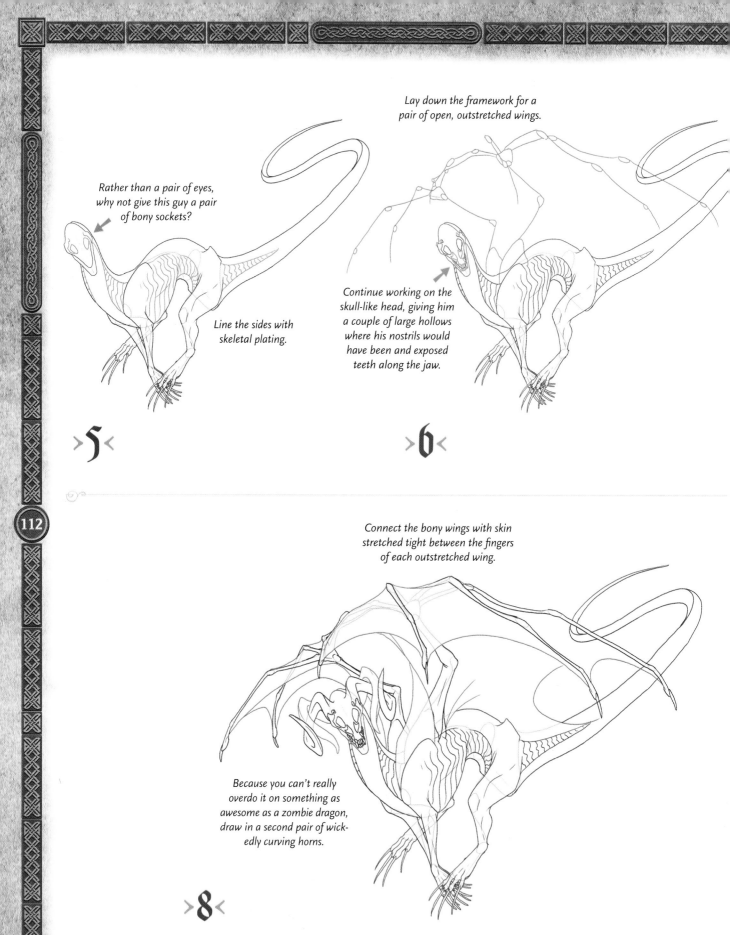

Rather than a pair of eyes, why not give this guy a pair of bony sockets?

Line the sides with skeletal plating.

>5<

Lay down the framework for a pair of open, outstretched wings.

Continue working on the skull-like head, giving him a couple of large hollows where his nostrils would have been and exposed teeth along the jaw.

>6<

Connect the bony wings with skin stretched tight between the fingers of each outstretched wing.

Because you can't really overdo it on something as awesome as a zombie dragon, draw in a second pair of wickedly curving horns.

>8<

*Refine the wing structure, adding
bony bat wings.*

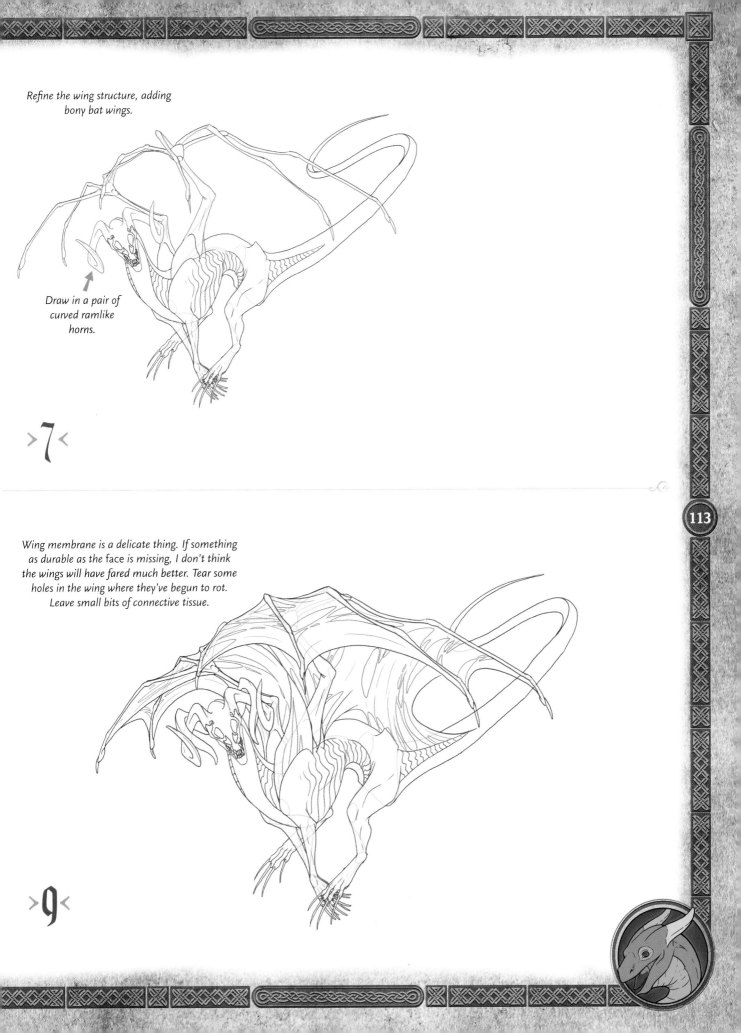

*Draw in a pair of
curved ramlike
horns.*

>7<

*Wing membrane is a delicate thing. If something
as durable as the face is missing, I don't think
the wings will have fared much better. Tear some
holes in the wing where they've begun to rot.
Leave small bits of connective tissue.*

>9<

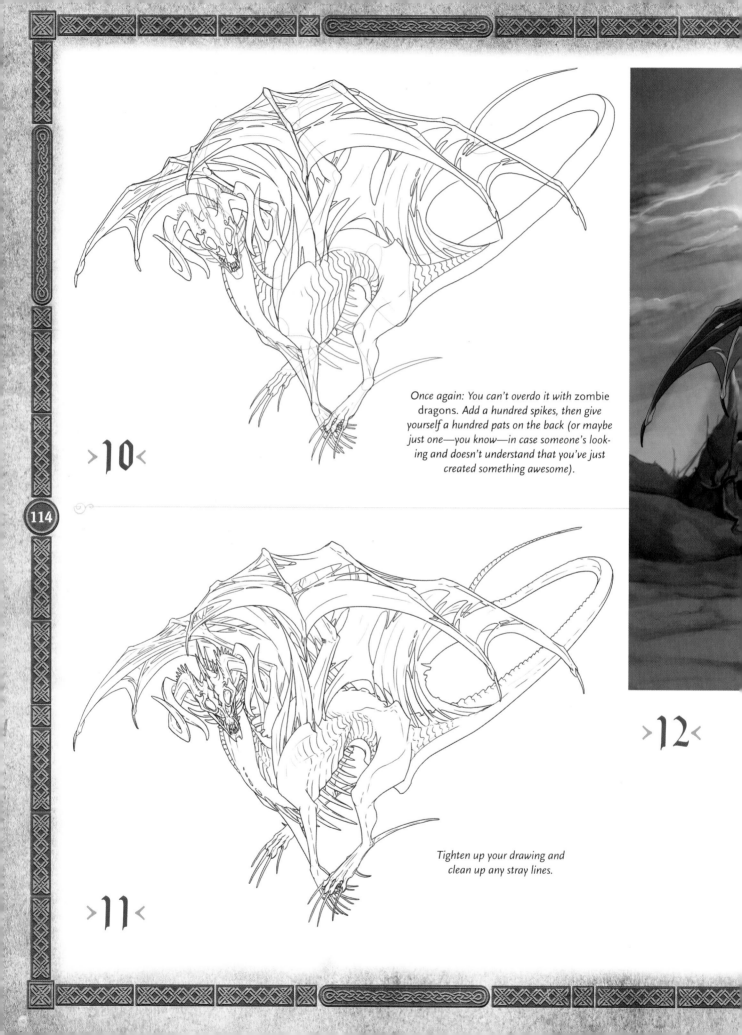

Once again: You can't overdo it with zombie dragons. Add a hundred spikes, then give yourself a hundred pats on the back (or maybe just one—you know—in case someone's looking and doesn't understand that you've just created something awesome).

>10<

>11<

>12<

Tighten up your drawing and clean up any stray lines.

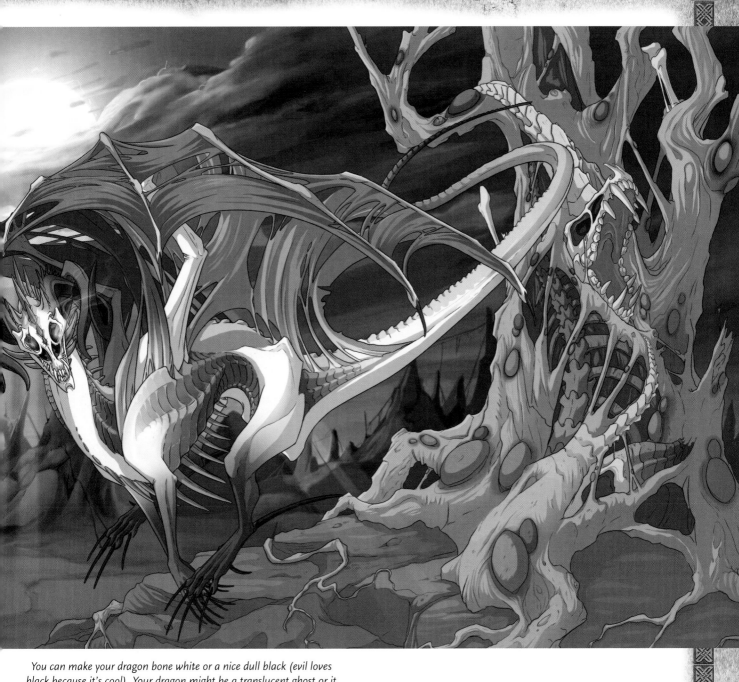

You can make your dragon bone white or a nice dull black (evil loves
black because it's cool). Your dragon might be a translucent ghost or it
might be tangible and rotting with a slightly greenish cast to its flesh.
Actually, you can make your undead dragon any darned color you want,
though I recommend staying away from bright, vibrant colors—while
your dragon may have been a brilliant ruby and sapphire in life, he's
probably faded a bit since he rose from the grave.

FEATHERED DRAGON

Not all dragons are leather and scales. Feathers and fur can be a part of their design just as easily! Consider whether you want your dragon to be fully feathered, partially feathered, or simply have feathered wings. Each choice will result in a significantly different design.

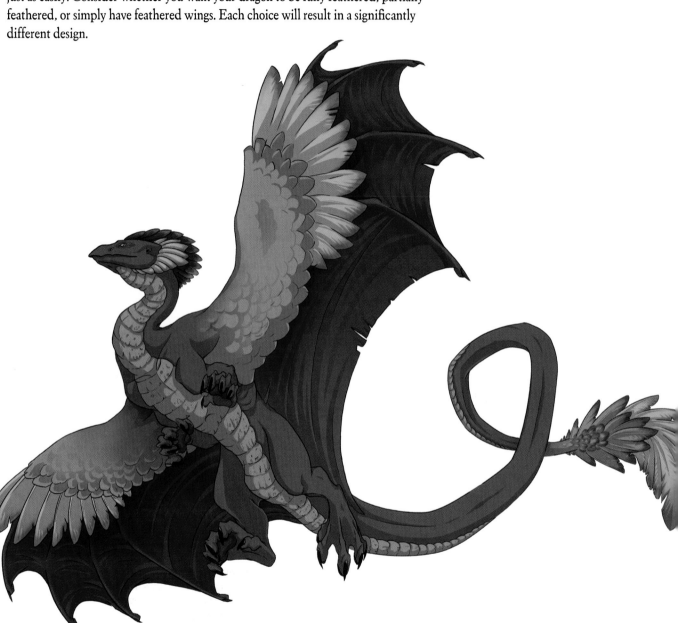

>1<

Draw the skull, chest and hips. Keep the
shapes simple and get the basic positioning
and proportions laid out.

>2<

Fill out the dragon and create a
neck, body and tail.

>3<

Pencil in a loose framework for the wings.
This one has bat wings layered with feath-
ers, but yours may have purely birdlike
wings if you wish!

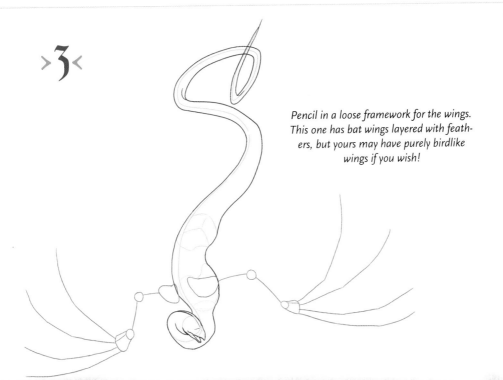

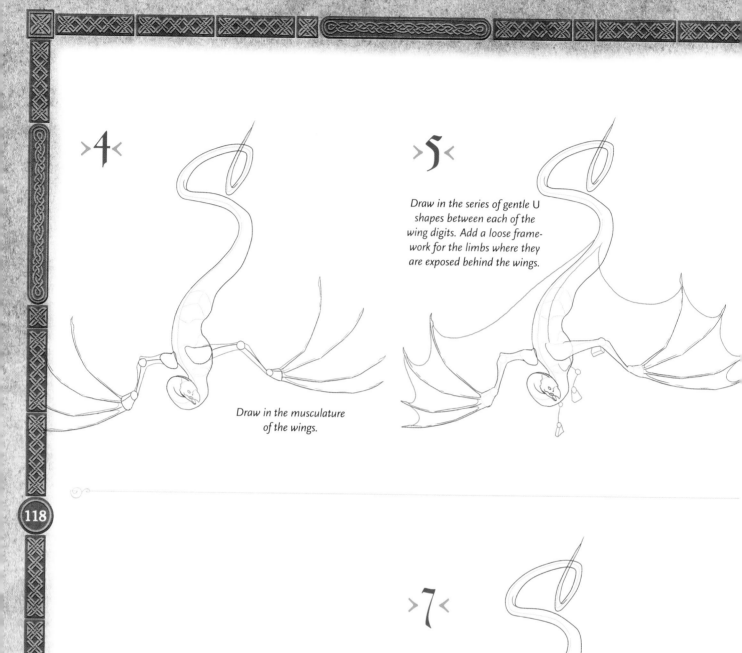

>4<

Draw in the musculature of the wings.

>5<

Draw in the series of gentle U shapes between each of the wing digits. Add a loose framework for the limbs where they are exposed behind the wings.

>7<

Draw in the shorter layered feathers using your guidelines to keep them in alignment.

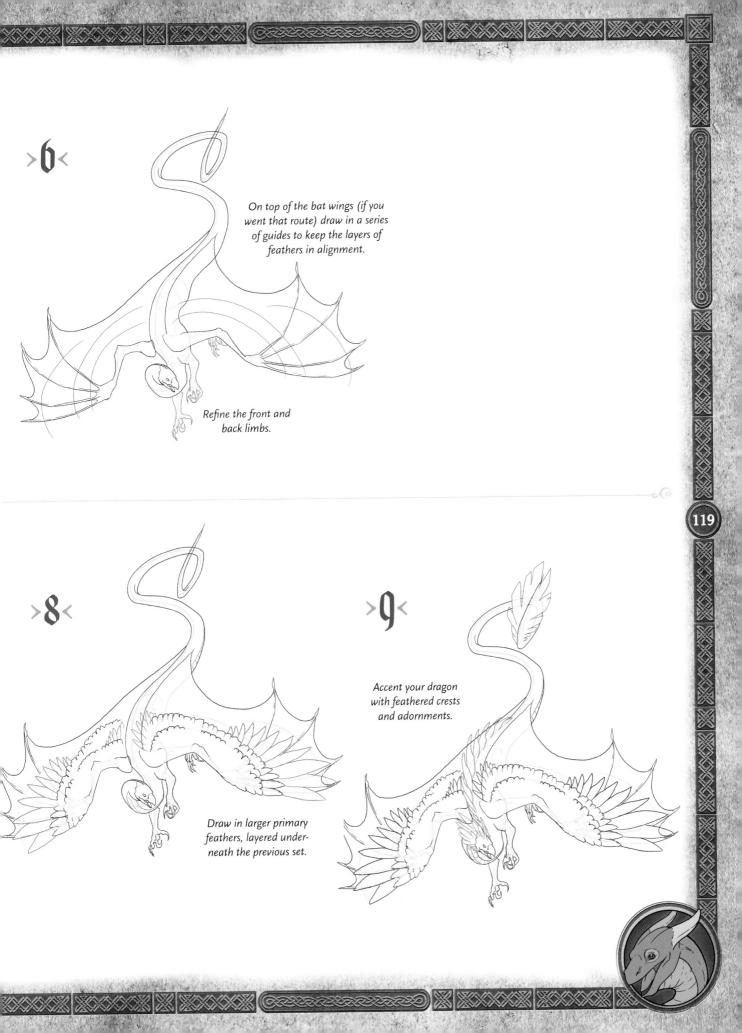

>6<

On top of the bat wings (if you went that route) draw in a series of guides to keep the layers of feathers in alignment.

Refine the front and back limbs.

>8<

Draw in larger primary feathers, layered underneath the previous set.

>9<

Accent your dragon with feathered crests and adornments.

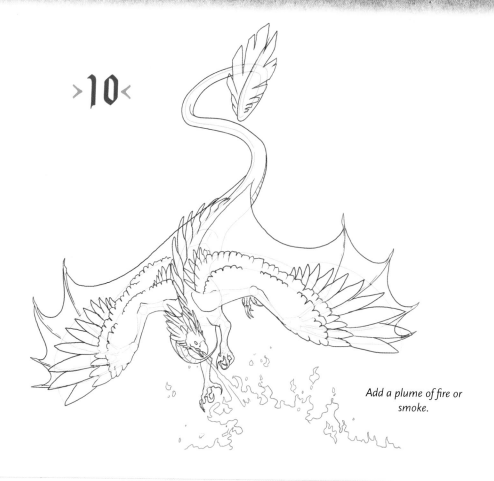

>10<

Add a plume of fire or smoke.

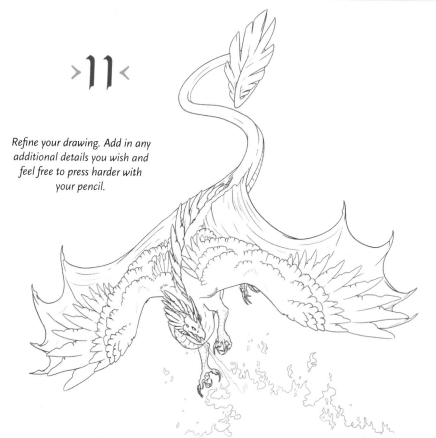

>11<

Refine your drawing. Add in any additional details you wish and feel free to press harder with your pencil.

>12<

The feathers can be colored and patterned after those of a bird, or they can be your own unique color scheme.

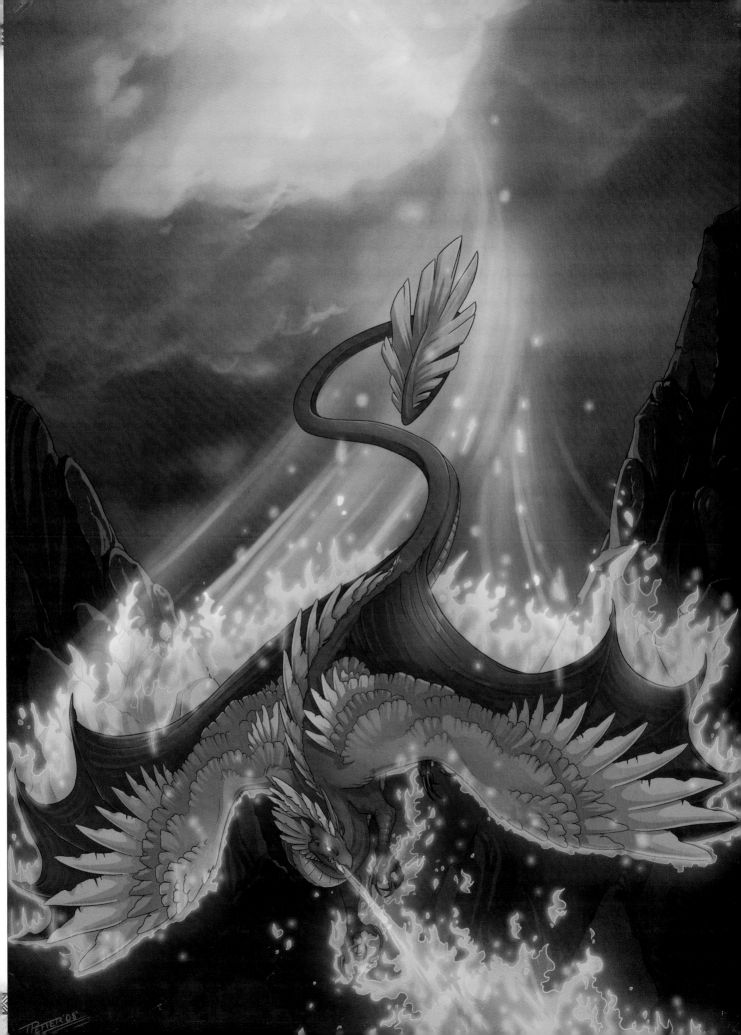

MESOAMERICAN DRAGON

The feathered serpent can be a fun dragon to draw with a long body that can twist and cling across your canvas. Your serpent can be just as compelling airborne as it is looping its coils over the branches of a tree. Consider adding accents to your serpent such as elaborate jewelry, tassels and gold decoration.

Huh. It says here that the feathered serpent, Quetzalcoatl, may have been worshipped as one of three agricultural cultural deities.

I find this of interest because...

what are you doing?

I'm uh...trying something.

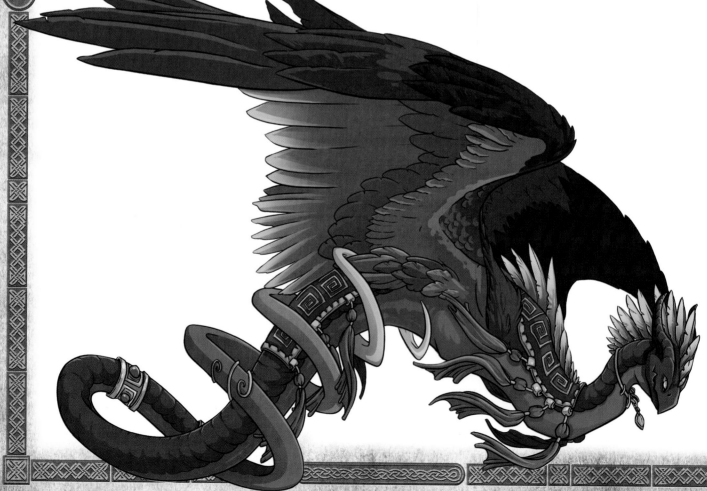

> 1 <

Draw the skull, and lay out the line of motion that the long, serpentine body will follow.

> 2 <

Fill out the body, giving him a long neck, thick body and tail that tapers to a point.

> 3 <

Having scales or a separation of top and bottom is useful in a body where there are no limbs to help you figure out front from back. It helps to show how the dragon's body twists and moves in the space.

Add a loose framework for the feathered wings.

Add a pair of horns, and fill out the wings to include thick muscles at the base.

> 4 <

> 5 <

Draw in a layer of short, rounded feathers near the top edge of the wing.

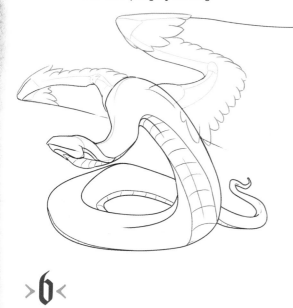

Draw in a layer of pointed secondary feathers.

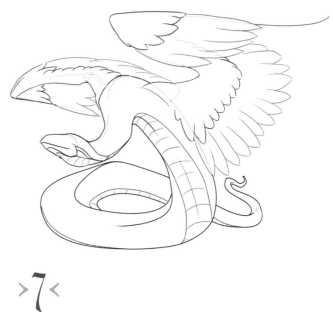

>**6**<

>**7**<

Details such as a row of feathers along your dragon's spine and sides can be attractive and fun!

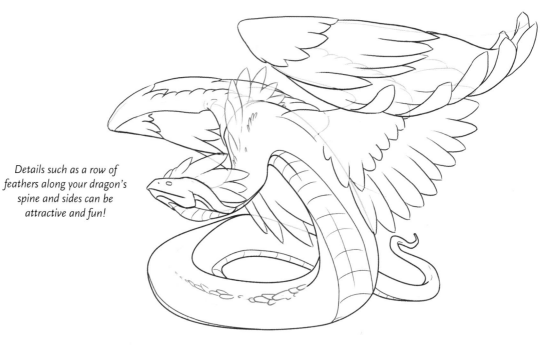

>**10**<

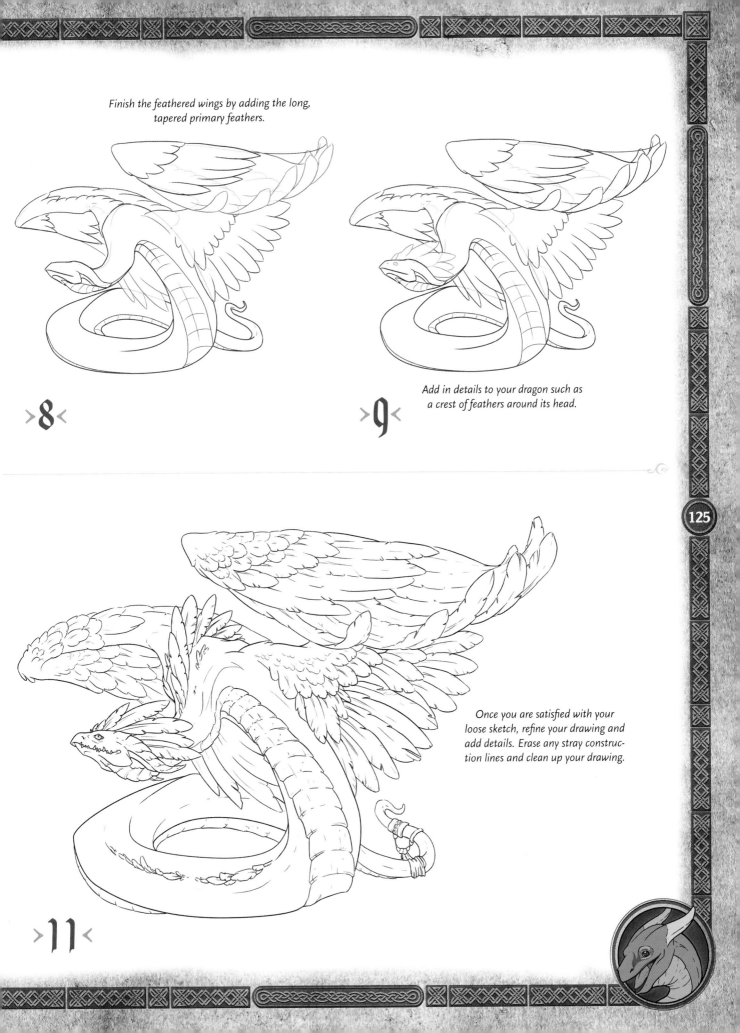

Finish the feathered wings by adding the long, tapered primary feathers.

>**8**<

Add in details to your dragon such as a crest of feathers around its head.

>**9**<

Once you are satisfied with your loose sketch, refine your drawing and add details. Erase any stray construction lines and clean up your drawing.

>**11**<

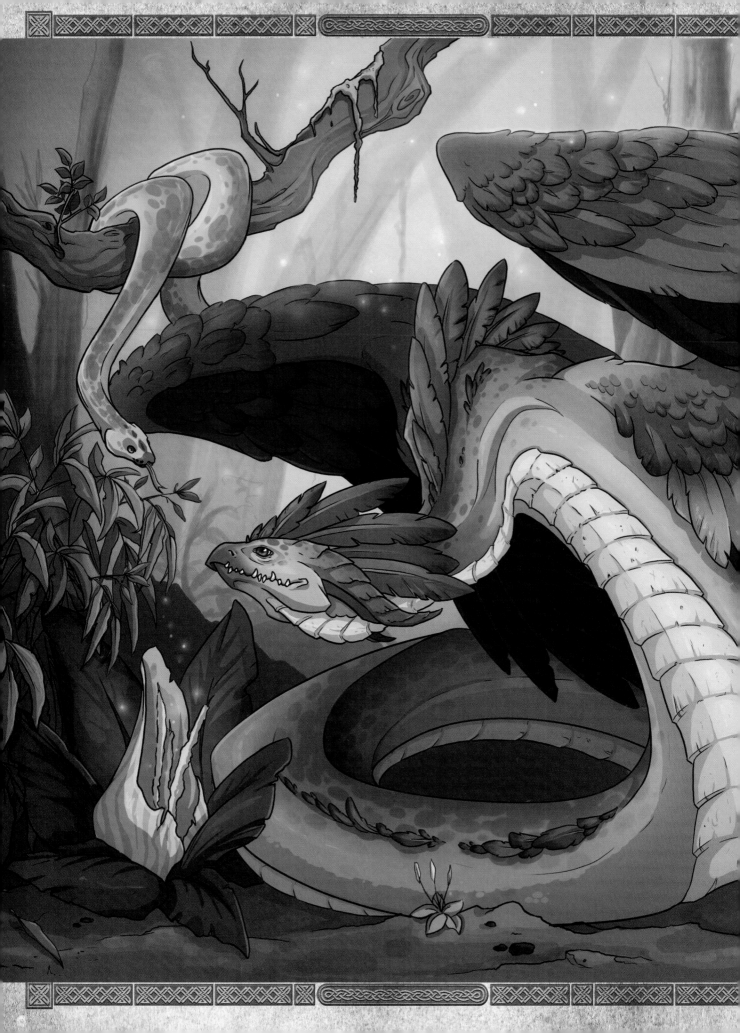

>12<

You can model the plumage after parrots and tropical birds, or use earthy tones to keep him camouflaged in the surrounding foliage.

DRAGON RIDER

Not all dragons will allow a smelly human on their backs as they soar through the skies. The few that do will often form close bonds with their two-legged companions. The dragon rider team has many uses. They can serve as an elite aerial force, a really classy cab service, perform in races, or deliver the post in an incredibly awesome way.

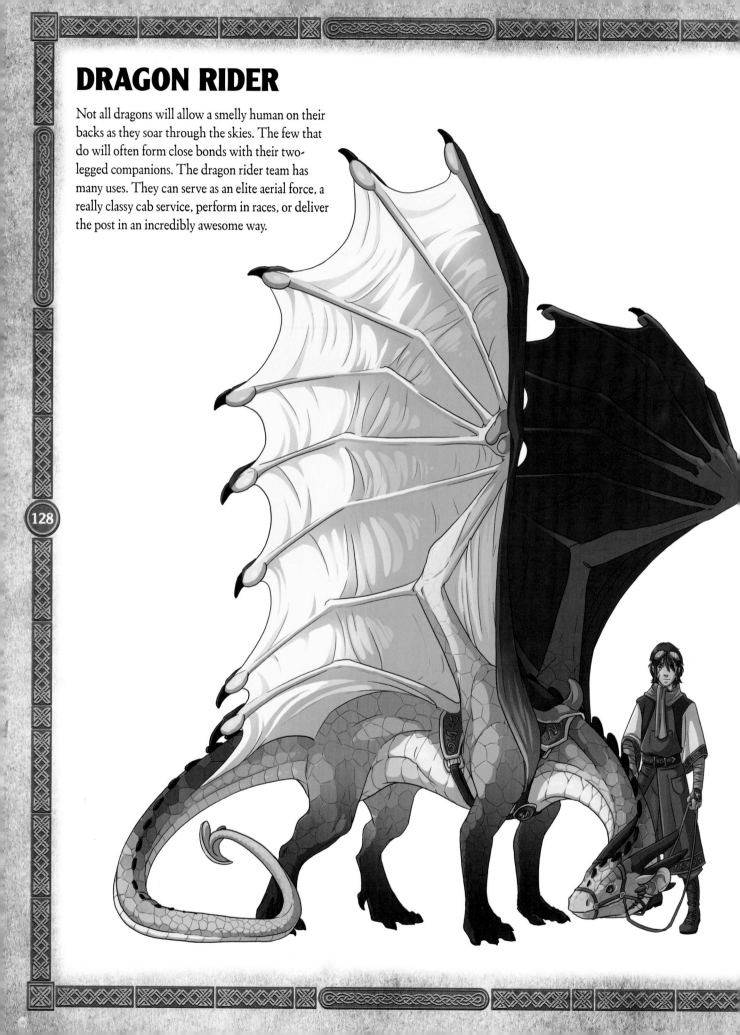

Keep the shapes simple and lay out the basic positioning and proportions of the dragon.

Fill out the body.

>1<

>2<

129

Pencil in a loose framework for the limbs.

Flesh out the simple lines and put in powerful muscles and sharp claws.

>3<

>4<

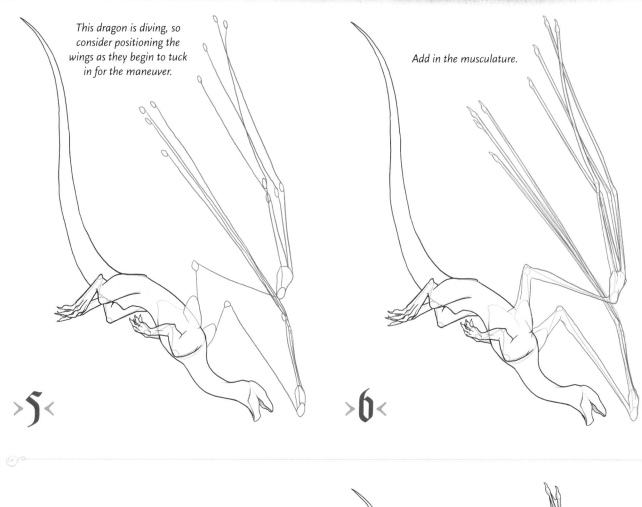

This dragon is diving, so consider positioning the wings as they begin to tuck in for the maneuver.

>**5**<

Add in the musculature.

>**6**<

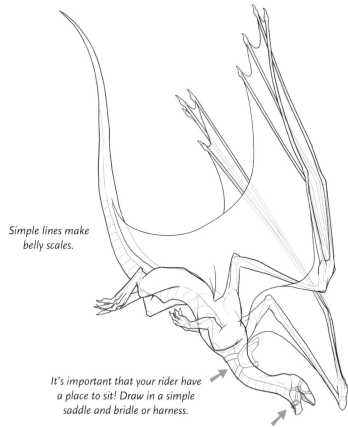

Simple lines make belly scales.

>**8**<

It's important that your rider have a place to sit! Draw in a simple saddle and bridle or harness.

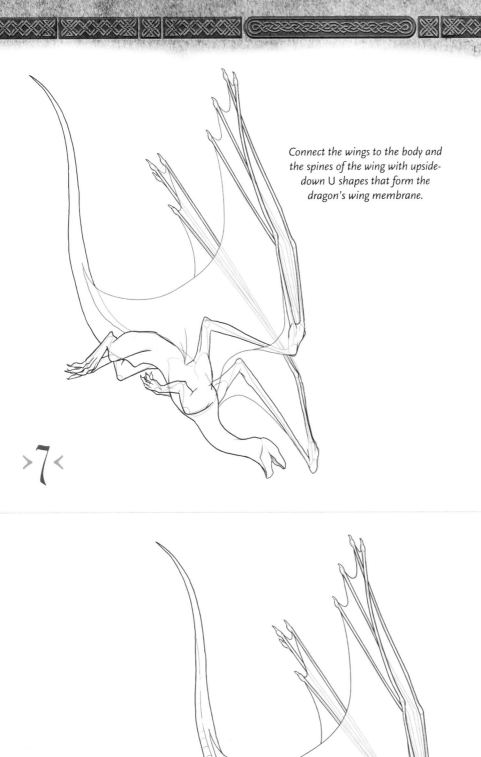

Connect the wings to the body and the spines of the wing with upside-down U shapes that form the dragon's wing membrane.

>7<

Add head frills.

Pencil in a simplified figure for the proportions and positioning of the rider. Since this dragon is diving, the rider is crouched and prepared for the maneuver.

>9<

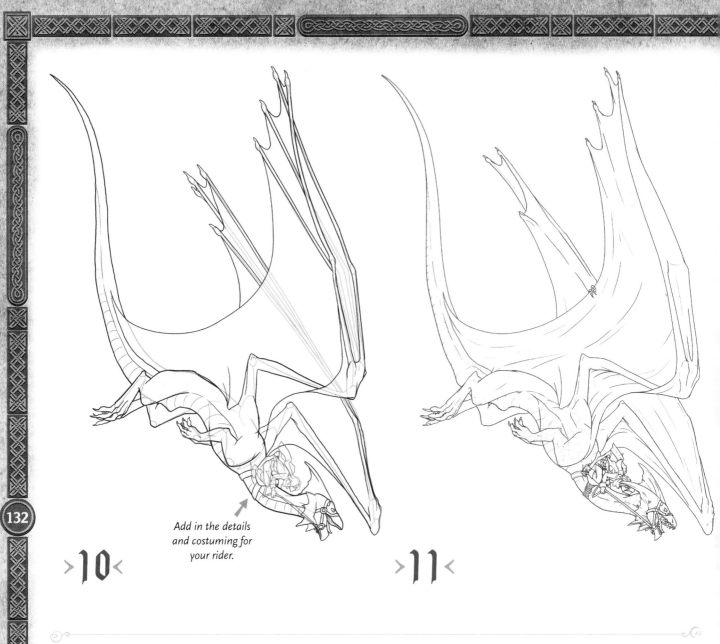

Add in the details
and costuming for
your rider.

>10<

>11<

>12<

The rider may have a uniform that
matches that of his fellows, or one that
coordinates with his dragon specifically.

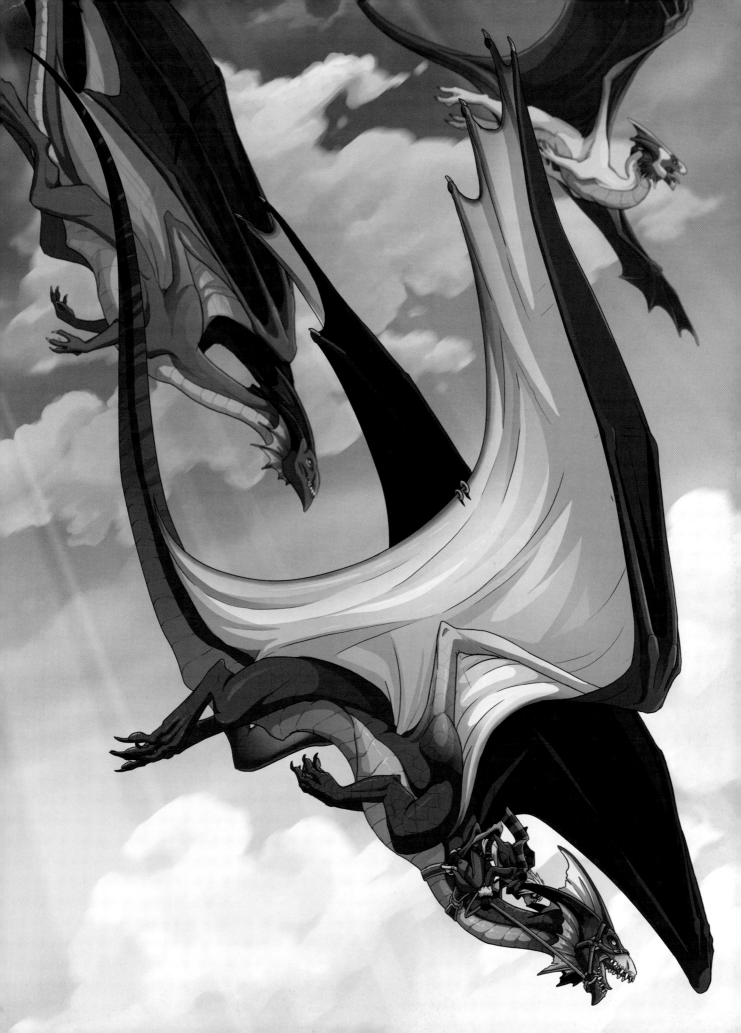

Digital Painting ✖ DRAGON SCENE

I am often asked how the illustrations in my books are finished in that "magic color step." First, know that finishing a drawing in watercolor is just as valid as markers, graphite, acrylic or computer graphics. You do not need to purchase a fancy computer, Adobe® Photoshop® and a tablet to finish pieces of art; this is simply the way that I do it most of the time. Even if you choose to finish your drawing digitally, there are a lot of different ways to work besides mine. The following tutorial is an overview for those who are curious how the illustrations in the book were finished.

For a more in-depth step-by-step demonstration of my coloring process, look for my video (available as a DVD or a download), *DragonArt: Digital Dragons* at the North Light Shop, www.northlightshop.com.

Equipment

- Pencil and paper (Over half of my drawings start in my sketchbook.)
- Scanner (A piece of computer hardware that allows me to scan in the drawings I make in my sketchbook, turning them into a file I can open and work with on the computer.)
- Computer with 3GB RAM and an Intel® Core ™ Quad processor
- Adobe Photoshop CS3 (The art software program I use to ink and color.)
- Wacom tablet (A piece of hardware that allows me to use a special digital pen to draw and color on a tablet surface. The pressure and strokes I use are translated into pixels on the screen.)

>1<

This is the result that you will likely have after finishing one of the demonstrations in the book—a line drawing without much in the way of color, line value, lighting or environment. I sometimes sketch this line drawing straight into my art program. Other times I draw in my sketchbook and scan in the result.

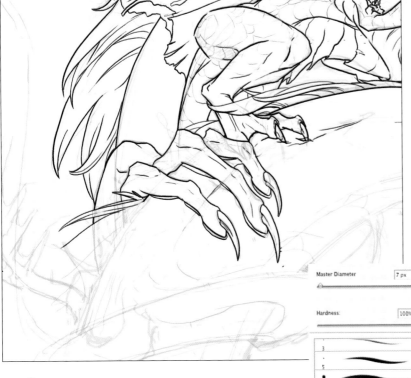

I open my scan or digital sketch in Photoshop. Here, I can work with layers. (Picture several clear sheets of plastic laid on top of each other.) I can paint on each transparent plastic sheet independently of its fellows. When they are put together, they create a single image, though each layer can be manipulated independently.

I put my scan on the bottom layer called sketch and create an empty layer on top of it called inks. I can now draw on top of my sketch, creating a clean inking.

I typically use a hard-edged 5–7 pixel brush that tapers according to pen pressure.

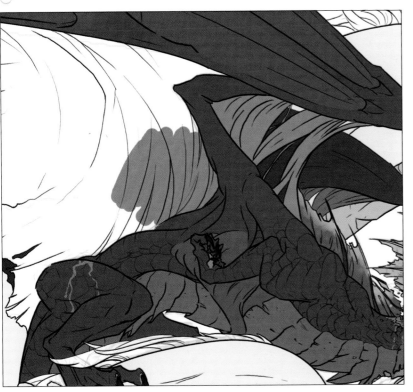

When my inking is finished, I lay down my base colors. I do this on a layer called flat colors that is under the inks, but over the sketch, covering it. (The sketch layer can be turned off or deleted. Its main purpose is to give me a guide to create my inking.) The colors that I lay down do not have any sort of lighting or shading applied to them yet.

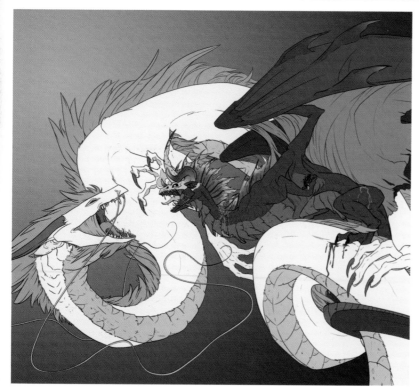

I lay in a simple gradient background called BG set behind my flat colors and inks. This gives me a very rough idea of my light source and the colors surrounding the dragons.

>4<

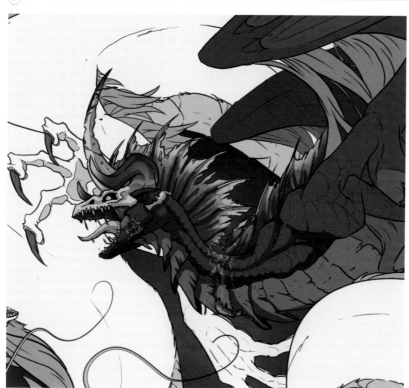

I create a layer called shadows underneath my line work, but above my flat colors. Because I want the lighting on the dragon to stay within the bounds of the color underneath it and not overlap onto the background, I will group the layer (resulting in the little arrow you see in my menu). This grouping will only allow my paint to show up where there are existing pixels on the layer beneath it. I set the layer mode to multiply, which is a darkening layer mode. Any paint I put down on a multiply layer will only darken the colors beneath it. I use this setup to paint in shadows on my dragon's body.

>6<

Working on the background layer, I use a hard-edged round brush that's opacity is tied to pen pressure.

I develop the background in much the same way as a traditional painting, building up colors and creating textures. Unlike a traditional painting I have an "undo" button, which I make good use of. Because I'm working with layers and all the background is underneath the colors of the dragon, I do not have to worry about my painting overlapping the creatures.

>5<

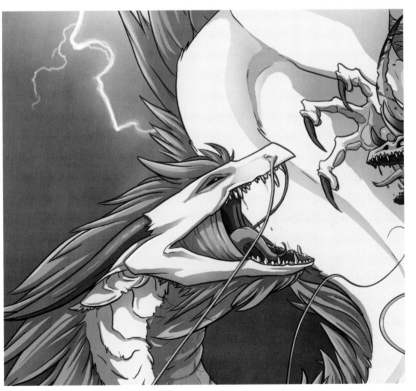

Above the shadow layer, but under the line work layer, I create a new layer called highlights. I group this layer so that it's also tied to the dragon's base colors, and set the layer mode to screen, a lightening layer mode. I then paint in colored pink highlights where the light would be hitting the dragons most brightly.

>7<

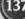

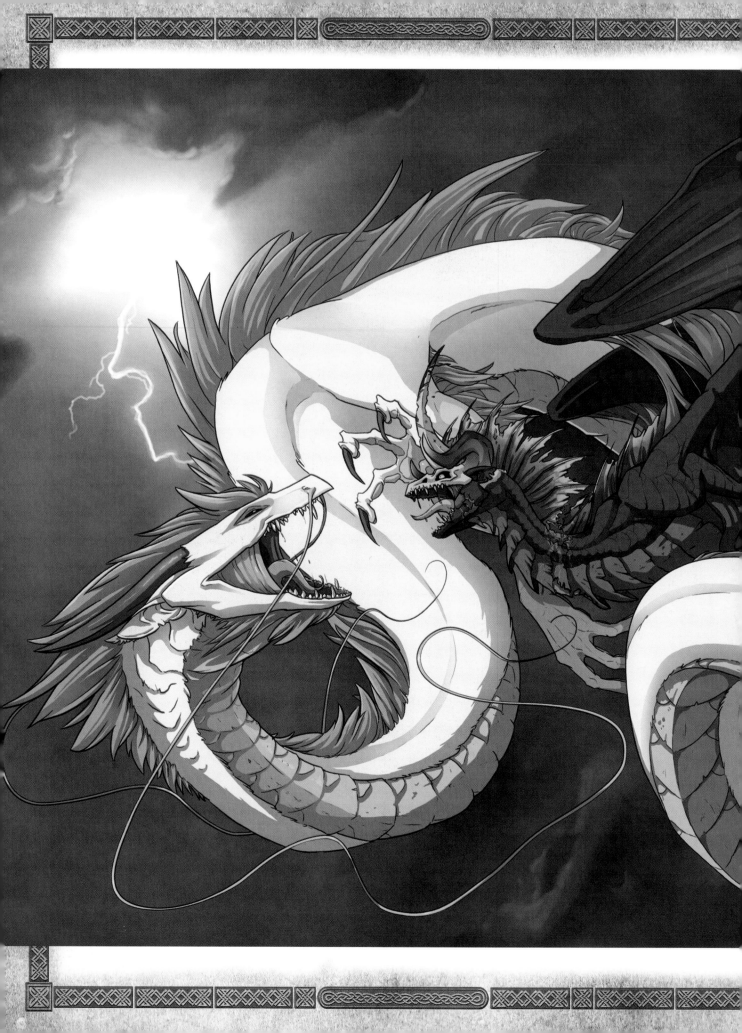

>8<

When the entire piece has been painted, I sit back and take a good long look. I make any final color tweaks, motion blurs, additional light and shadows that don't look quite right on the layer mode layers, and other final adjustments as I see necessary. I then save my file a final time and create a backup of it on a DVD or external hard drive; it doesn't take a fire or flood to destroy your digital artwork. All that's needed is a computer problem that wipes out your hard drive or corrupts your files. Having multiple backups of your artwork is a very good idea to keep it from disappearing for-ever due to an accident or unfortunate mishap.

139

INDEX

 Other fine IMPACT Books are available from your local bookstore, art supply store or online supplier. Visit our website at www.fwmedia.com.

18 17 16 15 8 7 6

DISTRIBUTED IN CANADA BY FRASER DIRECT
100 Armstrong Avenue
Georgetown, ON, Canada L7G 5S4
Tel: (905) 877-4411

DISTRIBUTED IN THE U.K. AND EUROPE BY DAVID & CHARLES
Brunel House, Newton Abbot, Devon, TQ12 4PU, England
Tel: (+44) 1626 323200, Fax: (+44) 1626 323319
Email: postmaster@davidandcharles.co.uk

DISTRIBUTED IN AUSTRALIA BY CAPRICORN LINK
P.O. Box 704, S. Windsor NSW, 2756 Australia
Tel: (02) 4577-3555

Library of Congress Cataloging in Publication Data
Peffer, Jessica, -
 DragonArt evolution : how to draw everything dragon / Jessica "NeonDragon" Peffer. -- 1st ed.
 p. cm.
 Includes index.
 ISBN 978-1-4403-0252-7 (alk. paper)
 1. Dragons in art--Juvenile literature. 2. Drawing--Technique--Juvenile literature. I. Title. II. Title: How to draw everything dragon. III. Title: Dragon art evolution.
 NC825.D72P437 2010
 743'.87--dc22 2010017862

Edited by Sarah Laichas and Mona Michael
Designed by Wendy Dunning
Production coordinated by Mark Griffin

Metric Conversion Chart

To convert	to	multiply by
Inches	Centimeters	2.54
Centimeters	Inches	0.4
Feet	Centimeters	30.5
Centimeters	Feet	0.03
Yards	Meters	0.9
Meters	Yards	1.1

ABOUT THE AUTHOR

J "NeonDragon" Peffer is a fantasy art illustrator and author of IMPACT's *DragonArt™: How to Draw Fantastic Dragons and Fantasy Creatures* and *DragonArt™: Fantasy Characters*. She runs a popular website, http://neondragonart.com, a community where fantasy art fans explore her art, comics, art instruction tutorials, products featuring her art, message boards, links and other features. She is a graduate of the Columbus College of Art and Design. She has also done character and logo commissions.

ACKNOWLEDGMENTS

I would like to thank Bec, Brandon, Cameron, Chris, Dana, Darren, Devin, Eric, Erich, Jake, Racheal and Rusty for listening to me ramble aimlessly about the book for hours on end. A shout-out to my guild mates at Black Omen for being amazing dorks and assisting me in my endeavours to procrastinate as long as possible. I want thank my editors Mona Michael and Sarah Laichas for countering those endeavors and helping to get the book finished so that the book you now hold in your hands actually exists. I'd like to thank Wendy Dunning for making the book a sparkly and awesome finished piece of wonder!

MORE from J "NEONDRAGON" PEFFER!